between the gaps

TO MY BEAUTIFUL MUM, MAUREEN

A New South book

Published by
University of New South Wales Press Ltd
University of New South Wales
Sydney NSW 2052
AUSTRALIA
www.unswpress.com.au

© Louise Hawson 2011
First published 2011

10 9 8 7 6 5 4 3 2 1

National Library of Australia
Cataloguing-in-Publication entry
 Author: Hawson, Louise.
 Title: 52 suburbs: a search for beauty in the 'burbs/by Louise Hawson.
 ISBN: 978 174223 239 3 (pbk.)
 Subjects: Suburban life – New South Wales
 – Sydney – Pictorial works.
 Suburbs – New South Wales – Sydney –
 Pictorial works.
 Sydney (NSW) – Pictorial works.
 Dewey Number: 994.41

This book is copyright. Apart from any fair dealing for the purpose of private study, research, criticism or review, as permitted under the Copyright Act, no part may be reproduced by any process without written permission. Inquiries should be addressed to the publisher.

Design Di Quick
Printer Everbest, China

This book is printed on paper using fibre supplied from plantation or sustainably managed forests.

52
suburbs
Louise Hawson

A SEARCH FOR BEAUTY IN THE 'BURBS

NEW SOUTH

1 WAHROONGA 10	14 HABERFIELD 128	27 STRATHFIELD 248	40 KIRRIBILLI 378
2 LAKEMBA 18	15 PYRMONT 136	28 REDFERN 256	41 COLLAROY 390
3 POTTS POINT 28	16 CLOVELLY 146	29 WATERLOO 266	42 MANLY 400
4 CRONULLA 38	17 SURRY HILLS 154	30 LA PEROUSE 276	43 VAUCLUSE 410
5 CABRAMATTA 46	18 INGLESIDE 164	31 BALMAIN 286	44 HURSTVILLE 422
6 EVELEIGH 54	19 LIDCOMBE 172	32 WOOLLOOMOOLOO 296	45 DULWICH HILL 436
7 CASTLECRAG 64	20 NEWTOWN 182	33 DURAL 306	46 SUMMER HILL 448
8 HARRIS PARK 72	21 BRIGHTON-LE-SANDS 190	34 WINDSOR 316	47 PADDINGTON 458
9 BLACKTOWN 80	22 GLEBE 200	35 DARLINGHURST 326	48 PENRITH 470
10 AUBURN 88	23 EASTWOOD 210	36 BOTANY 336	49 MAROUBRA 482
11 BONDI 100	24 LIVERPOOL 220	37 SYDNEY CBD 346	50 GRANVILLE 492
12 MARRICKVILLE 112	25 RANDWICK 230	38 BONNYRIGG 358	51 ALEXANDRIA 504
13 BANKSTOWN 120	26 CAMPBELLTOWN 238	39 ARNCLIFFE 368	52 MILSONS POINT 516

intro

'WHERE DO you live?' It's probably the first question people ask you when you're travelling. Without thinking, most people who call Sydney home would reply 'Sydney.' But do they really? Don't they really live in Glebe or Wahroonga or Surry Hills? How many 'Sydneysiders' actually stray far from their own corner of the city?

I used not to. In fact, until last year most of Sydney was foreign territory – of its 683 suburbs I had visited just a handful. And that was after 30 years of living here.

The realisation I was a stranger in my own city may never have occurred to me had it not been for one dastardly white-tailed spider. Late in 2007, while sleeping in my safe suburban apartment, the little critter crawled into my bed and sank its dirty fangs into my thumb. Long story short, I ended up in hospital with life-threatening septicaemia, cellulitis and an infection so bad it rotted the flesh of said thumb. At one point the doctors said I might lose my whole hand. Right hand, not good, I thought to myself. Would make it terribly tricky to chop the vegies. Luckily the infection abated and I ended up losing just half a thumb that was then refashioned with flesh from various parts of my body.

Eew, as my daughter would say. But the spider did me a big favour. I'd just been sleeping, minding my own business, and I'd almost checked out – or at the very least, lost a hand. What was I doing working my butt off in a job I'd long outgrown when life could so easily be snuffed out? It was time to stop wasting the precious stuff and do something I'd always wanted to do – photography.

Taking photographs is like a meditation I can actually do, when my mind empties and I'm totally present. And right or wrong, moving through the world with a camera in my hand makes me feel like I'm free to stick my nose into whatever takes my fancy. Culture, religion,

architecture, urban design, people ... whatever. But as much as I loved it, I never once thought I could do it seriously. Instead, I'd made my living drifting in and out of ad agencies as a copywriter, taking breaks when I got itchy feet to do other creative projects. They always involved ideas, words and images – video cameras, even – but never stills cameras.

Then the spider bit me and I decided, bugger it, I'd rather eat baked beans for the rest of my life than not do the one thing that really excited me.

It helped that digital photography had come of age, making it easy to experiment and snap away like a mad thing without it costing an arm and a leg.

So I bought myself a good digital SLR camera and started thinking about how and what I wanted to photograph. While I was dreaming up ideas I began wandering around my own suburb, photographing things that caught my eye. Street names etched in the pavement. Garden gates so rusty they looked like they could disintegrate at any moment. Classic old cake shops that would one day be given a soulless modern makeover. In other words, things that were old and ordinary – and in danger of being 'upgraded' – but that I found beautiful.

It got me thinking: how much 'ordinary beauty' was hanging on by its rusty hinges in other suburbs? And then it hit me. I had no idea, no visual picture of most of my own city.

Sure, I'd grown up in Hong Kong but I'd been back in Sydney for 30 years. How could I lust to travel overseas when I hadn't even explored my own backyard? And I'm not talking Uluru or Perth. I had no idea what happened just half an hour away in suburbs like Arncliffe or Penrith.

Worse still, the only impression I had of some suburbs was derived purely from the occasional negative newspaper headline. 'Riots in Cronulla', 'Trouble in Lakemba', 'Violence in Liverpool'. Surely there was more to these places than just the flare-ups.

Suddenly I had my project. I realised that the only way to find out about these places – my own city – was to go there and see for myself. I decided I would photograph and share what I discovered in an online blog and call it *52 Suburbs* – one suburb a week for a year.

Aside from far-flung suburbs I'd never visited, I also wanted to include suburbs I was more familiar with but had never really looked hard at.

But this wasn't going to be some sort of travel guide to the 'burbs. I was after the beauty in these places, meaning the old and faded or revitalised and repurposed, as well as the beauty of different people, cultures and religions.

I also decided I would present the majority of the images as diptychs – pairs – and add a caption. I'm not sure why but there's something deeply satisfying about

marrying disparate images that have nothing in common save for one striking similarity. It could be a pattern, colour or shape, anything really. Alternatively, the two images can be completely different but when placed side by side with a caption, they tell some sort of story. Nothing too serious but not total fluff either.

I thought maybe family and a few friends might drop by the blog for the occasional look-see. Never did I think it would gather the momentum that it did, with more than 5000 people from all around Sydney, Australia and the world visiting it every week and up to 10 000 page views.

That was the first surprise – that it wasn't just me who was curious about the backyard of Sydney, the parts you never see on glossy tourist brochures. And it wasn't just me who found great beauty in the faded, decaying and suburban.

I often wonder why I've never been curious about my own city before. In my twenties I was more concerned with relationships, friends and the big question of what to do on a Saturday night. Who cared what happened in Blacktown or La Perouse when your heart was breaking or your hangover was so bad it took all your strength just to walk to the corner shop? In my thirties it was more about trying to make a baby and working hard to try and throttle a mortgage. It wasn't until I had reached my early forties that I felt calm enough to stand still for a moment and think about what I really wanted to do (thanks largely to that lurking spider). I had finally come out the end of a long on-again, off-again relationship that had consumed me for two decades. I had finally produced my beautiful daughter. And the mortgage on my apartment was small enough for me to think I could do it – dedicate a year to a project that really excited me.

So what did I discover? That my year of walking slow and looking hard was a journey on four different levels.

The most obvious journey was the physical one I took around the place. And what I discovered was that as beautiful as the postcard images of Sydney are – a city that had risen up out of a stinky slum and fashioned itself into a shiny diamond, glittering for all the world to admire – there was so much more uncelebrated and unique beauty in the 'burbs.

Much of that beauty comes from the fact that Sydney ain't filled with the bronze Aussies the world thinks it is – but with skin tones right across the spectrum. This was the most wonderful shock of the whole project, to discover that the Sydney where most people live, and the Sydney that's growing at the rate of knots, isn't filled with Anglo whities like me but with myriad ethnicities and cultures. Of course I already *knew* this. But it's one thing to read about Sydney being

multicultural and quite another to wander down a main road and feel like you've been transported to another country – be it China, Korea, somewhere in the Middle East – and that you, as an Anglo, are the minority.

While there are pockets of these communities all around Sydney, the majority live in the western suburbs where red-brick apartment blocks and gum-ball machines still rule. Faded suburbia, in other words, that acts as a surreal backdrop to the many colourful and exotic cultures that reside there.

The next big journey I went on was delving into subjects and ideas that arose out of my travels. One suburb would have me racing home to research a certain architectural period or a particular religion; another, the Aboriginal situation. Never before had I related so much to the saying that travel broadens the mind – even if it was within my own city. I was expanding my horizons one suburb at a time.

The third journey was a photographic one. I feel like I've spent a year courting the intense Australian

SOME NOTES ON MY 'METHOD'
I'm often asked about the diptych approach to my images and how I go about it. Sometimes I go in search of an image to complement or contrast with another image. But very often the images find me. Serendipity, perhaps. Then other times I'll be out, hunting and gathering my images, and I won't see the connections – it isn't until I get back and put all the thumbnails on my desktop that I'll suddenly spy two images just made for one another.

Another question I get asked a lot is how I approach people to take their photo. It gets easier the more you do it but it also seems to be less daunting if I think of it in terms of 'work', a project I've been assigned to do. And if I ever feel nervous about asking someone, I think to myself, what would hurt more, a second of discomfort or missing the shot? The thought of missing out is always more painful so inevitably I just do it. And guess what? They're usually the most rewarding interactions and images.

And how did I choose my 52 suburbs? I certainly never drew up a master list. In fact, most often I didn't know where I was going from one week to the next. I would hover over the map and wait for inspiration. Sometimes I became curious about a place after reading something. Other times it was out of necessity – I was too busy to roam far so I would choose a suburb close to home. And often I would just pick somewhere randomly. For the hell of it.

light, respecting its blinding brightness and working my day around it. I also learnt that extremely shallow depth of field, where only part of an image is in focus and the rest just drops away, creating a deliciously dreamy feel, really floats my boat. And I discovered that as much as I love documenting the beauty of the ordinary in the built environment, I also love to take portraits of people — the more unusual the better.

But perhaps the most fruitful journey of all was the one I took into the murky depths of my own soul. I discovered the secret to happiness is to stick my nose around a corner and document what I find. And to encounter people I'd never normally run into and move through those invisible walls we place around ourselves, to connect, if only for the briefest time. I also learnt that I'm pretty hopeless without a project that challenges me, and what scares me most is the prospect of staying stuck inside my comfort zone. Give me fear any day.

All four journeys were pretty amazing in what has been one of the most fulfilling years of my life – so while I may be much poorer after a year of little income, I feel so much richer for the experience.

One follower of the blog described the project as a 'love letter to Sydney'. While I didn't start out with that intention, I think it ended up becoming one. It felt like getting to know a person, learning about their flaws as well as their good points, and loving them all the more for it.

Next time I have a friend from overseas in town, I'll still show them the usual suspects (I doubt I'd feel like I'd seen Paris without seeing the Eiffel Tower), but I'll be sure to take them for a whizz around the suburbs too. Dare I say, the real Sydney.

I also no longer feel like a Glebe-sider, or an Avalon-sider, or a Clovelly-sider. For the first time ever I can stand tall and with hand on heart proudly proclaim: I am a Sydneysider! Where do I live? Sydney, mate.

In the end this project is also a time capsule – Sydney as it was in 2009/2010. Which is the ultimate power of photography – to freeze time and capture moments that would otherwise disappear without trace. Because, as those nice boys from *The Rocky Horror Picture Show* would say, time is fleeting.

There are lots of people to thank – and I do so with great enthusiasm on page 528. But there is someone, or rather something, that this project would not have been possible without. Yes, I'm talking about you, World Wide Web – I couldn't have done it without you, baby. Not only did you freely dispense your great knowledge about the suburbs and the subjects they inspired, you also made it possible for me to share this great adventure with a whole bunch of wonderful people from as far away as Ulan Bator and Reykjavik. Who knew that pixels combined with computer code could be so much fun?

www.52suburbs.com

wahroonga

THURSDAY, 3 SEPTEMBER 2009

I'M KICKING off *52 Suburbs* with a visit to Wahroonga, 22 kilometres north-west of the CBD. I know, I know, *Wahroonga*? Isn't that one of those polite Upper North Shore suburbs with lots of trees, big houses and not much else? Well, yes and no.

I'd never contemplated putting Wahroonga on my list, mainly because I've been there before and could see no reason for going again. That was before I got the flyer in the mail about the Fifties Fair at Rose Seidler House, both of which I'd always wanted to visit but strangely never had. Where were they? Wahroonga!

Excited, I made the long trek north from my apartment in Clovelly. The usual weekend sounds of tennis balls flying back and forth and pristine four-wheel drives gliding past were replaced by booming rockabilly and the din of more than 5000 Fifties fans making their annual pilgrimage to the iconic Rose Seidler House.

I felt like a kid in a lolly shop, not knowing where to look first: a shining example of mid-century modern architecture surrounded by beautiful Australian bush, or the adoring fans so perfectly garbed

they looked like they'd just walked straight off the set of *Mad Men*.

A few days later, on my second visit to the suburb, I stumbled on the 1969 Gerry Rippon 'Liquorice Allsorts' house. Like Rose Seidler, it seems to welcome the landscape in with open arms and celebrate Australia's riches of sun, light and air.

SOME HISTORY. Wahroonga is an Aboriginal word meaning 'our home'. Which it was, of the Kuringgai people for tens of thousands of years until the British arrived. The area was first settled in 1822 by a soon-to-be-wealthy convict landowner. While convicts no longer reside there, it remains the domain of the wealthy.

VERDICT Certainly many would consider Wahroonga beautiful, filled with grand mansions and manicured gardens. But where I found joy was in its temporary infiltration by a frenzy of '50s fans and a few buildings that seemed completely out of place – and yet so perfectly at home in the country we live in.

orange curtains

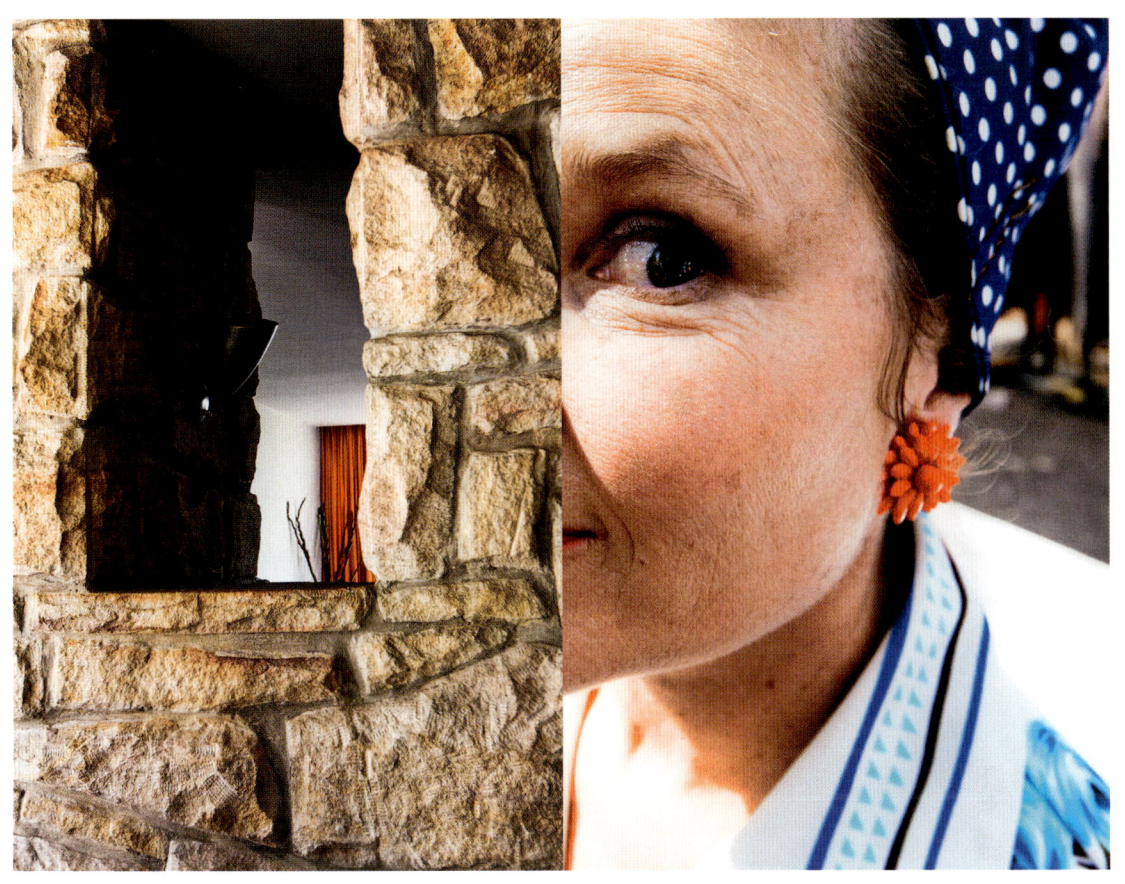

glimpse

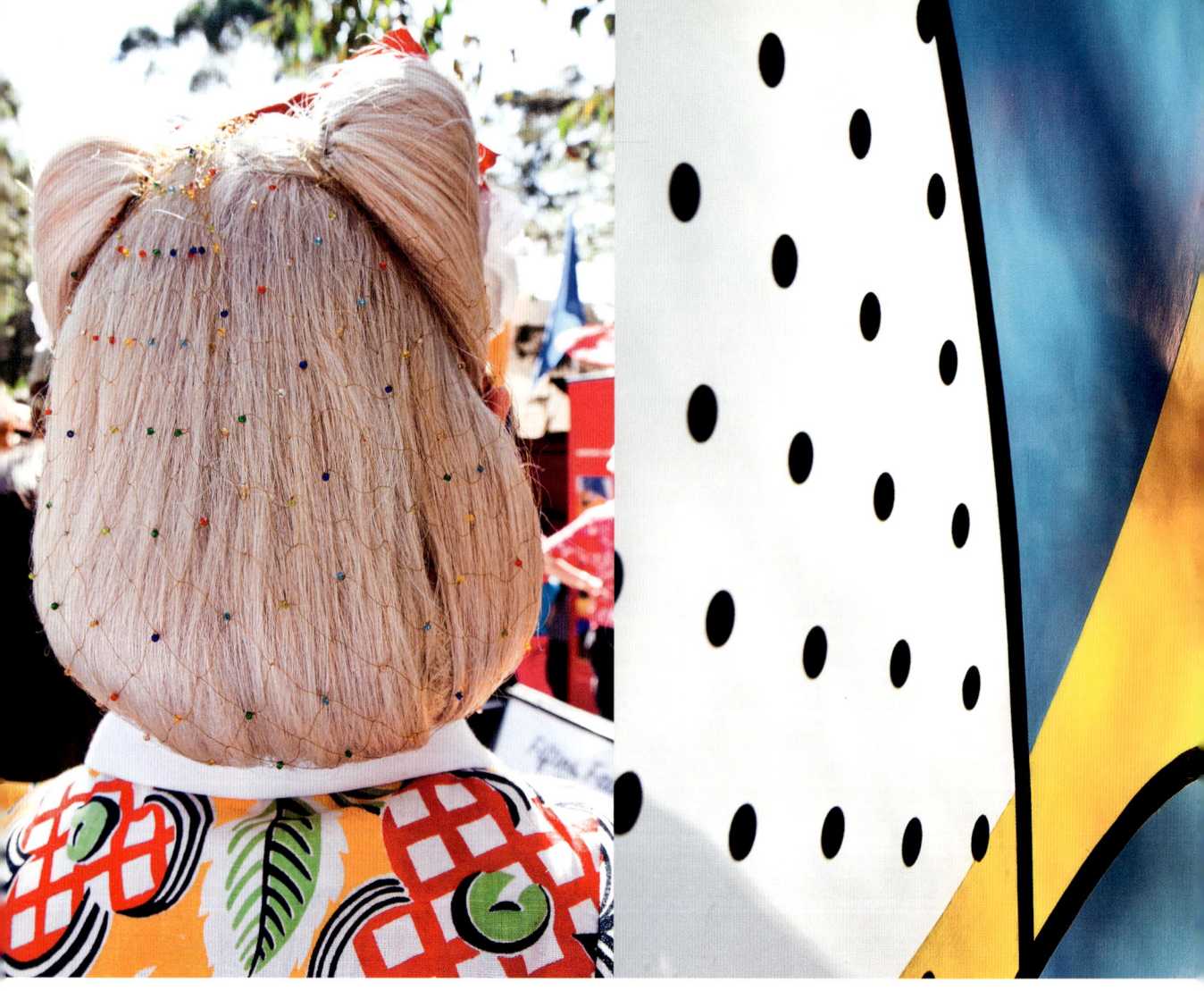

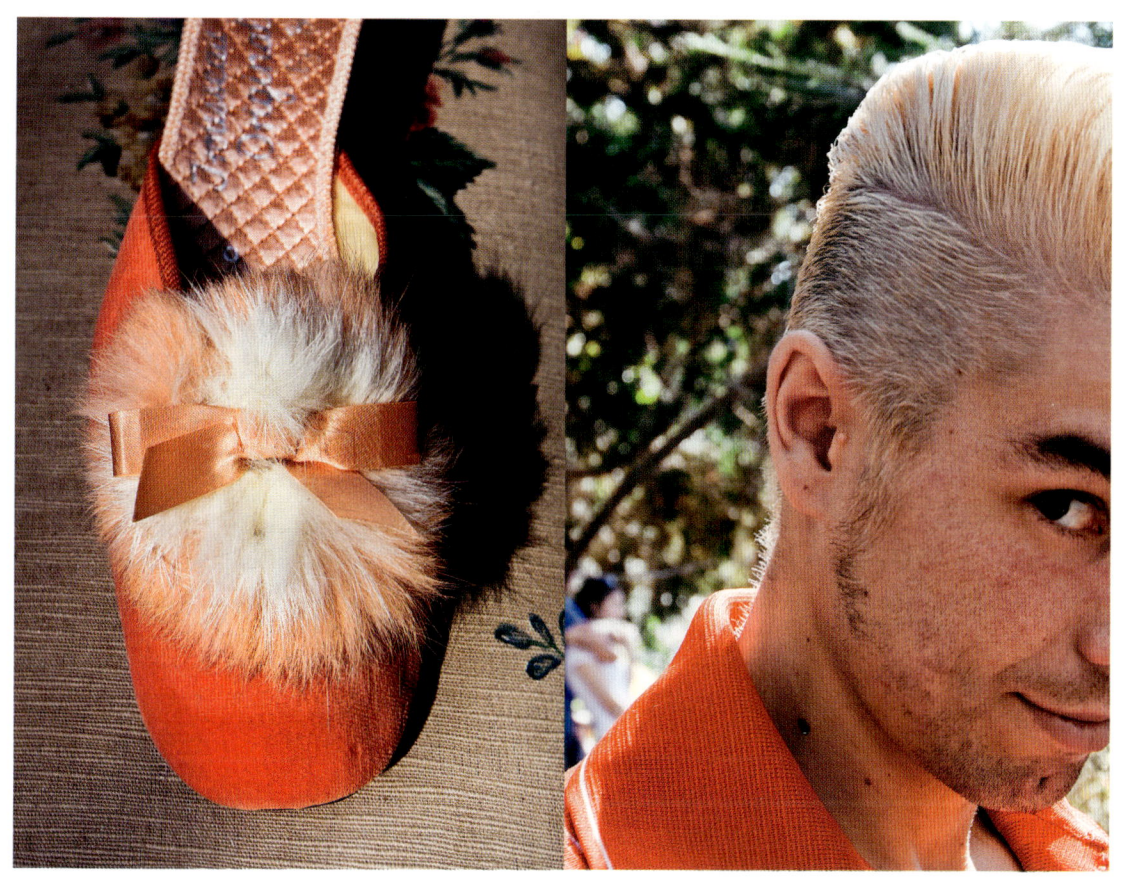

< *dotty about spots* *hey mister*

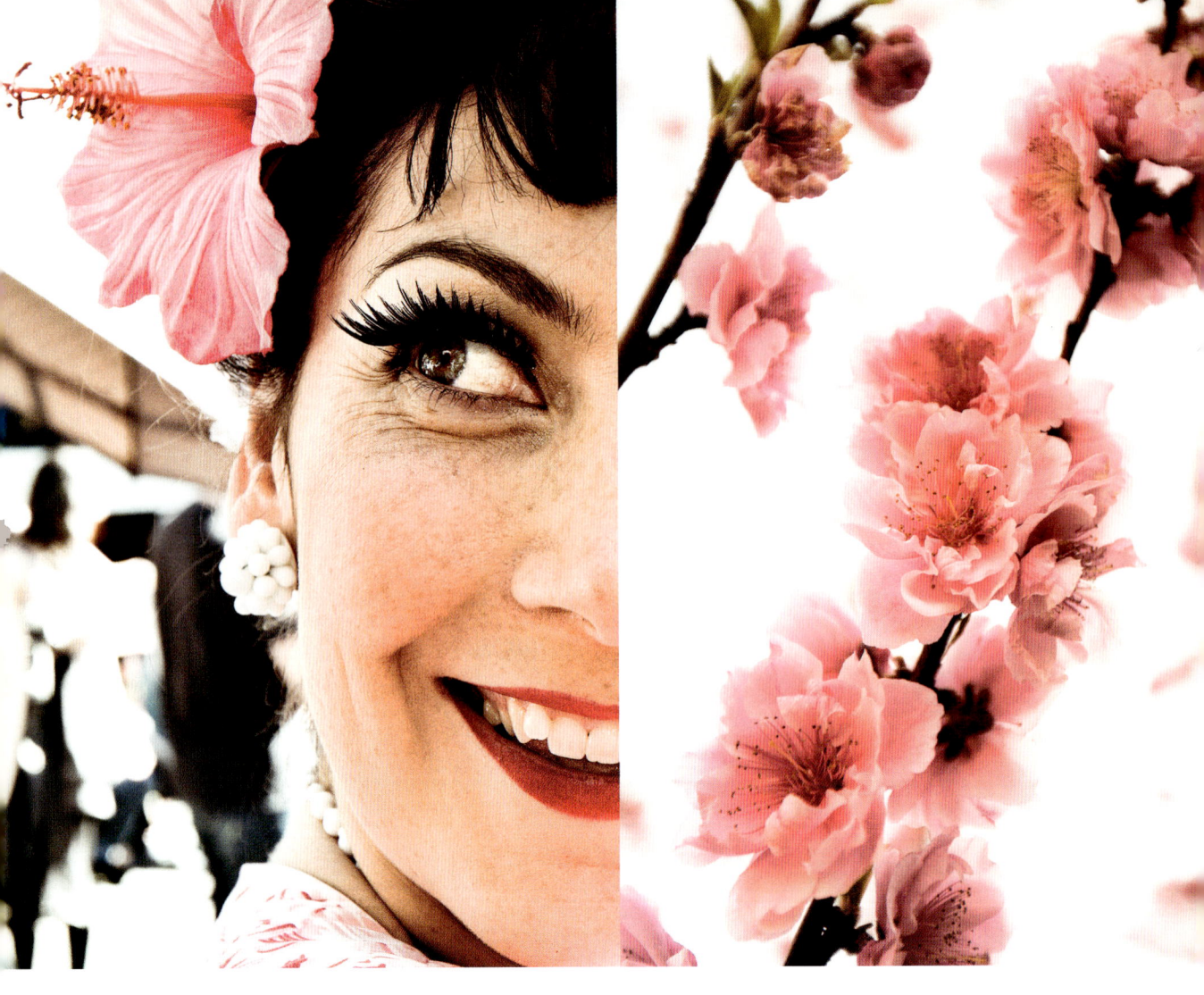

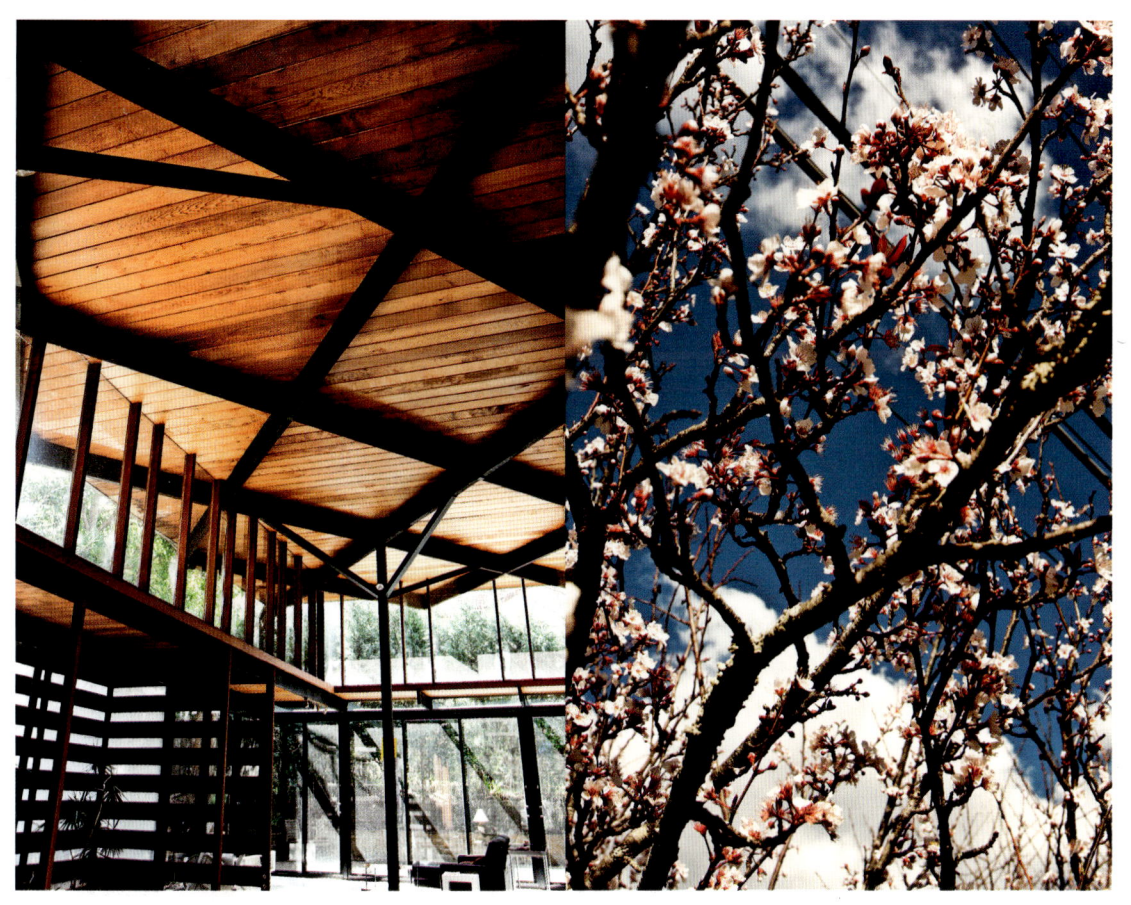

< peachy beams

Lakemba

SATURDAY, 12 SEPTEMBER 2009

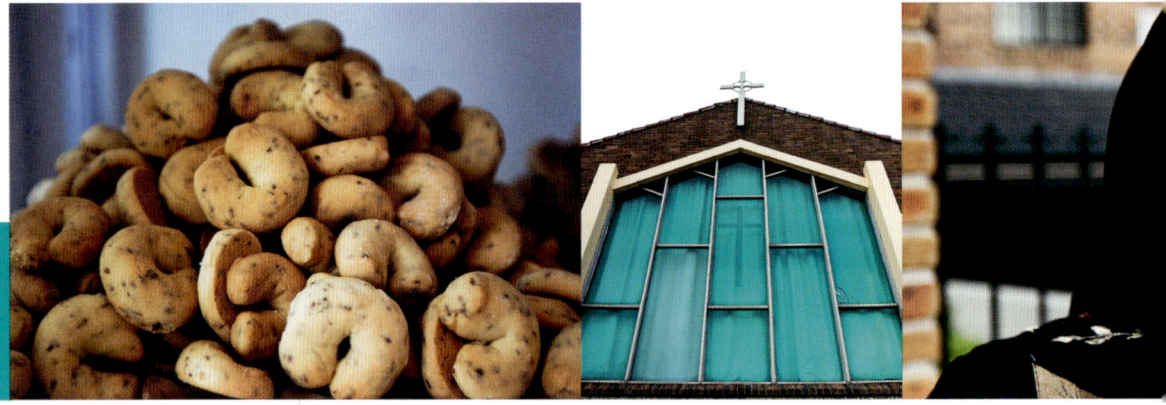

FOR SUBURB No 2, I decided on Lakemba. Why? Because all I'd ever heard about Lakemba was that at some point there'd been some trouble with the mosque there. I wasn't even sure what trouble. How could I know so little about somewhere in my own city? It was pathetic. Time to go see.

Before I set off I did a quick google search to increase my knowledge of the suburb from nothing to at least something. I discovered that Lakemba, a suburb 15 kilometres south-west of the city centre, was originally known as Potato Hill thanks to its spud farms, and was eventually named after a local mayor's property, which was in turn named after a Fijian island.

I also read that while most people regarded Lakemba as a Lebanese Muslim suburb, it was in fact much more ethnically diverse, with a large population of Vietnamese, Chinese, African, Indian and Pakistani.

And that 'trouble' I had a vague memory of? My googling revealed that it happened during the 2005 Cronulla Riots when religious and

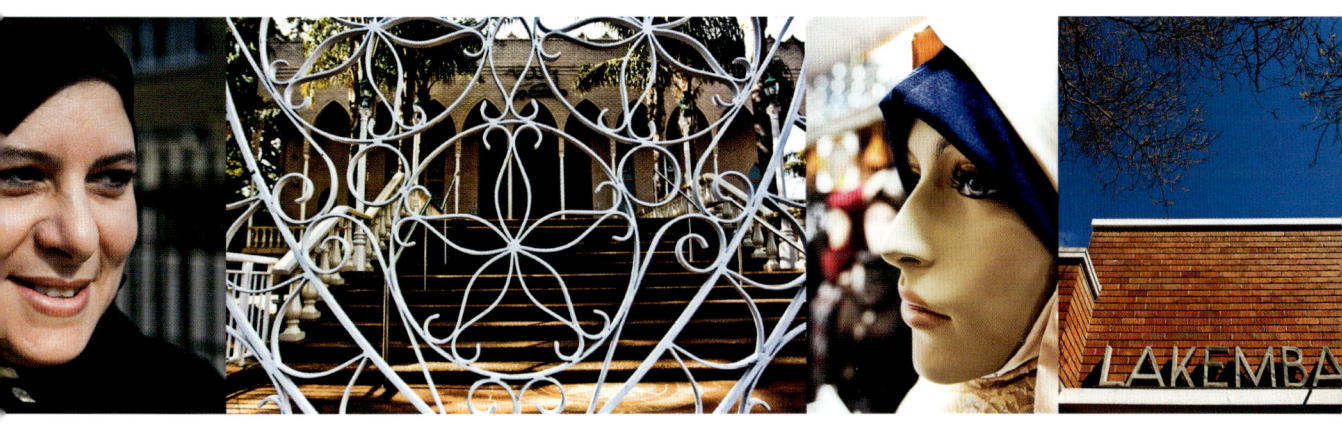

racial tensions had come to a head, and the Lakemba Mosque was the meeting place for angry youths. 'Research' completed, I headed off, arriving at Lakemba around 40 minutes later.

VERDICT Okay, so here's how it went. I did one lap of the main road and almost kept driving. This Sydney bore no resemblance to the Sydney I knew. The people, the signage, the food – all Lebanese, with the occasional Chinese fruit and veg shop thrown in. There wasn't another single whitie like me to be seen. I was a minority and it felt plain weird.

And I was going to get out of my car with my big fat camera and start snapping away? It just felt wrong, like I was intruding.

Eventually I pushed myself out of the car, spied a bakery and some kindly looking faces and asked nervously if it would be okay to take their photo. Of course, they replied. And that was it. I was away.

Lakemba is another world. But how amazing to be able to visit another world right in the middle of your own city.

19

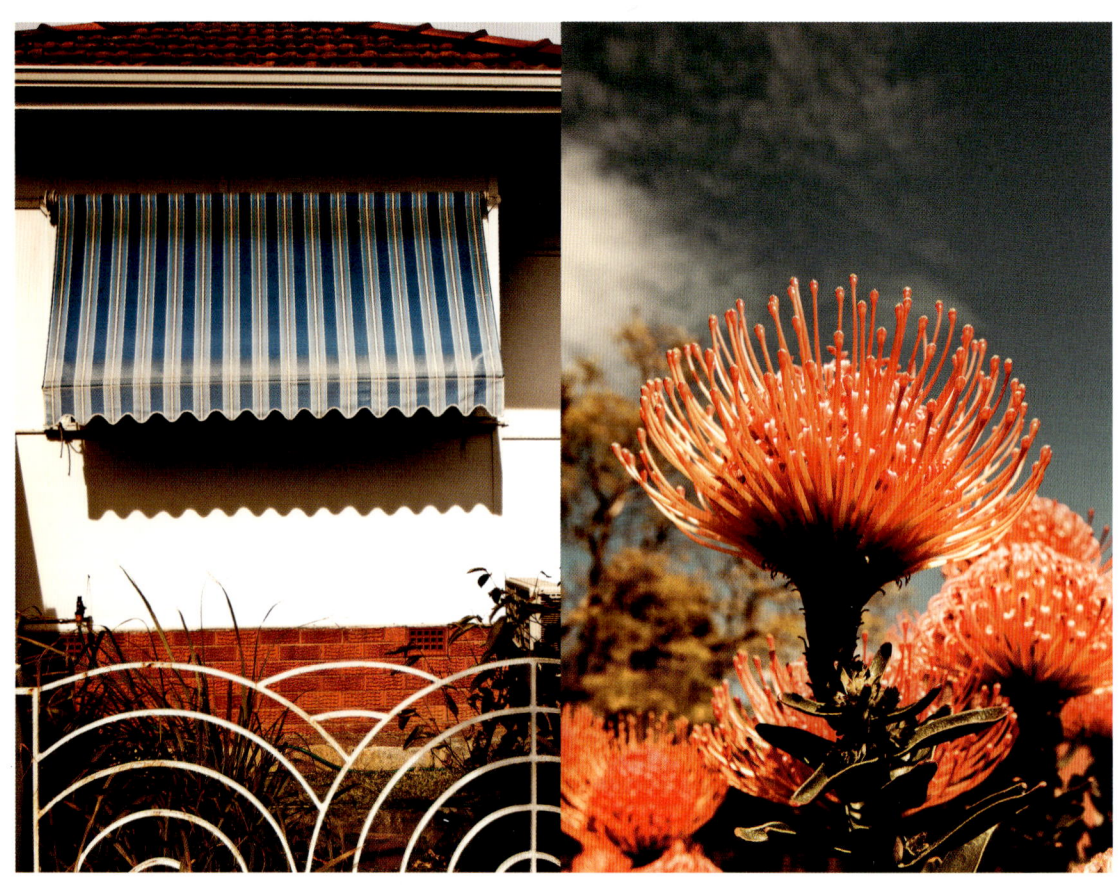

sun worshippers

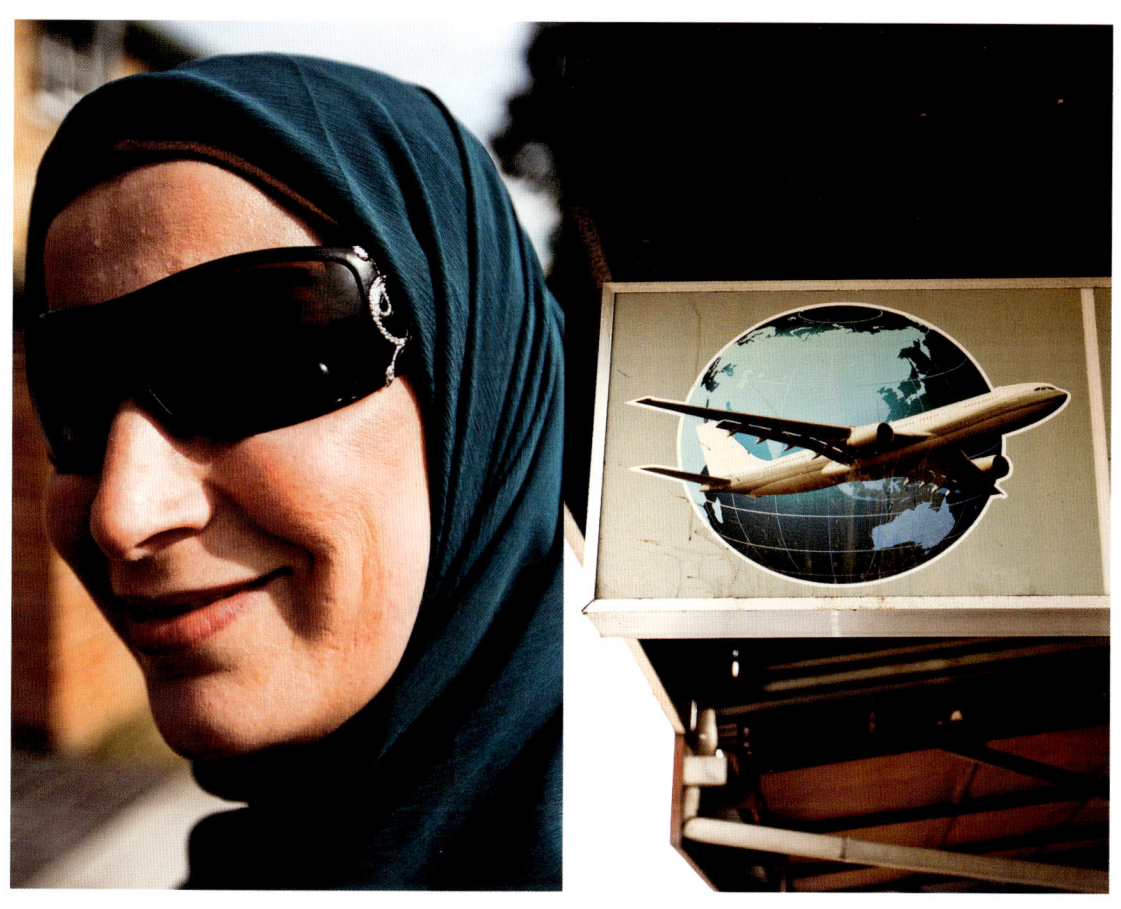

from far far away

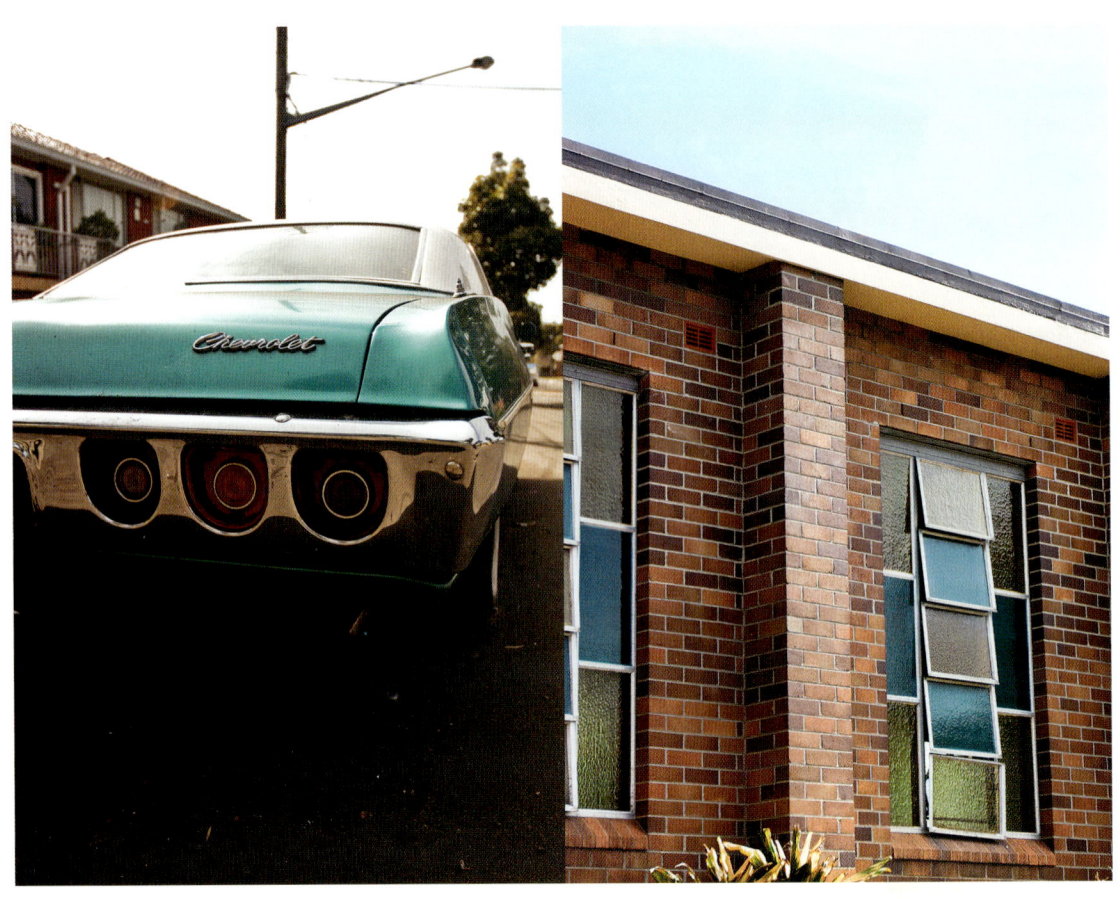

different religions

here's hoping >

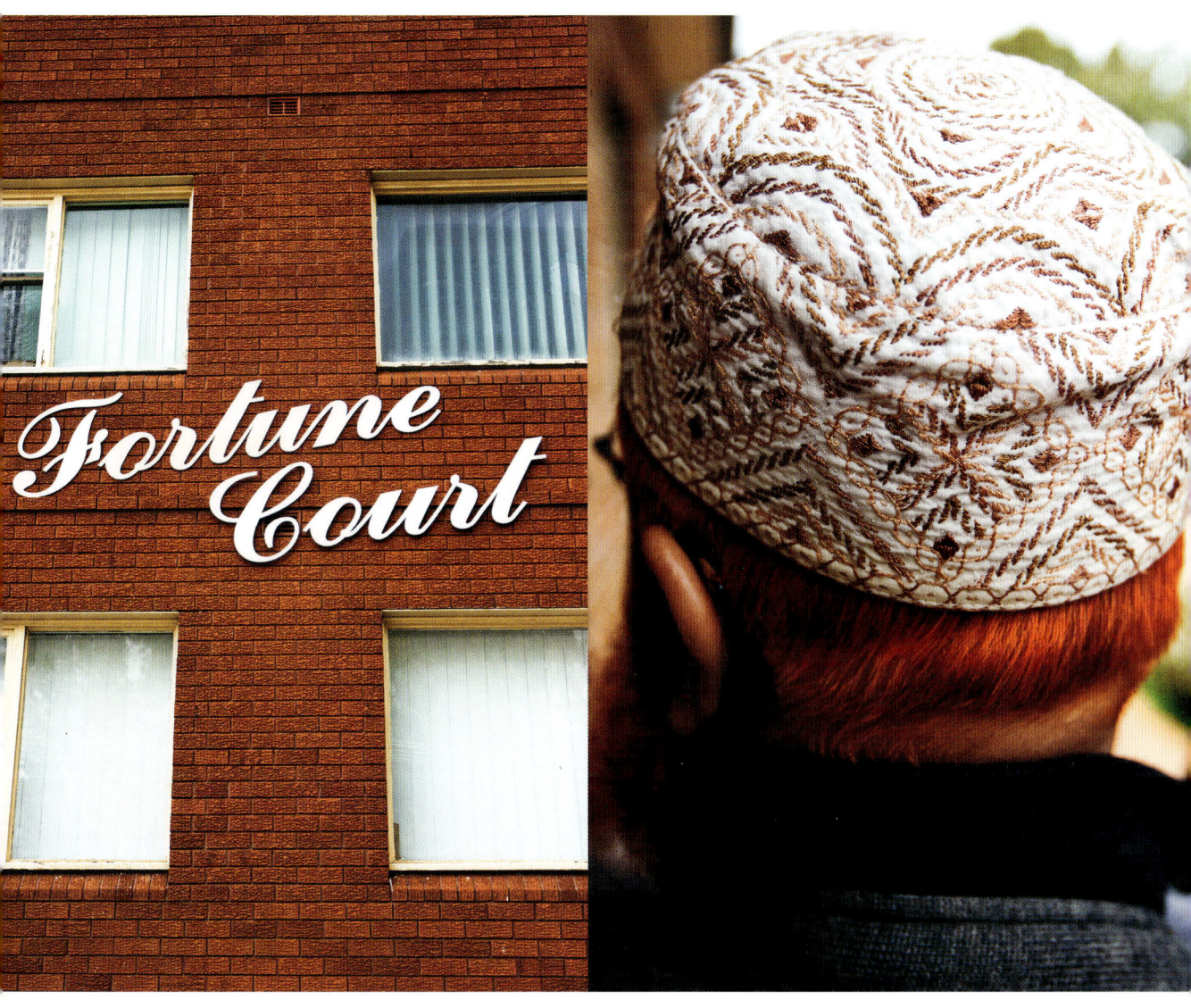

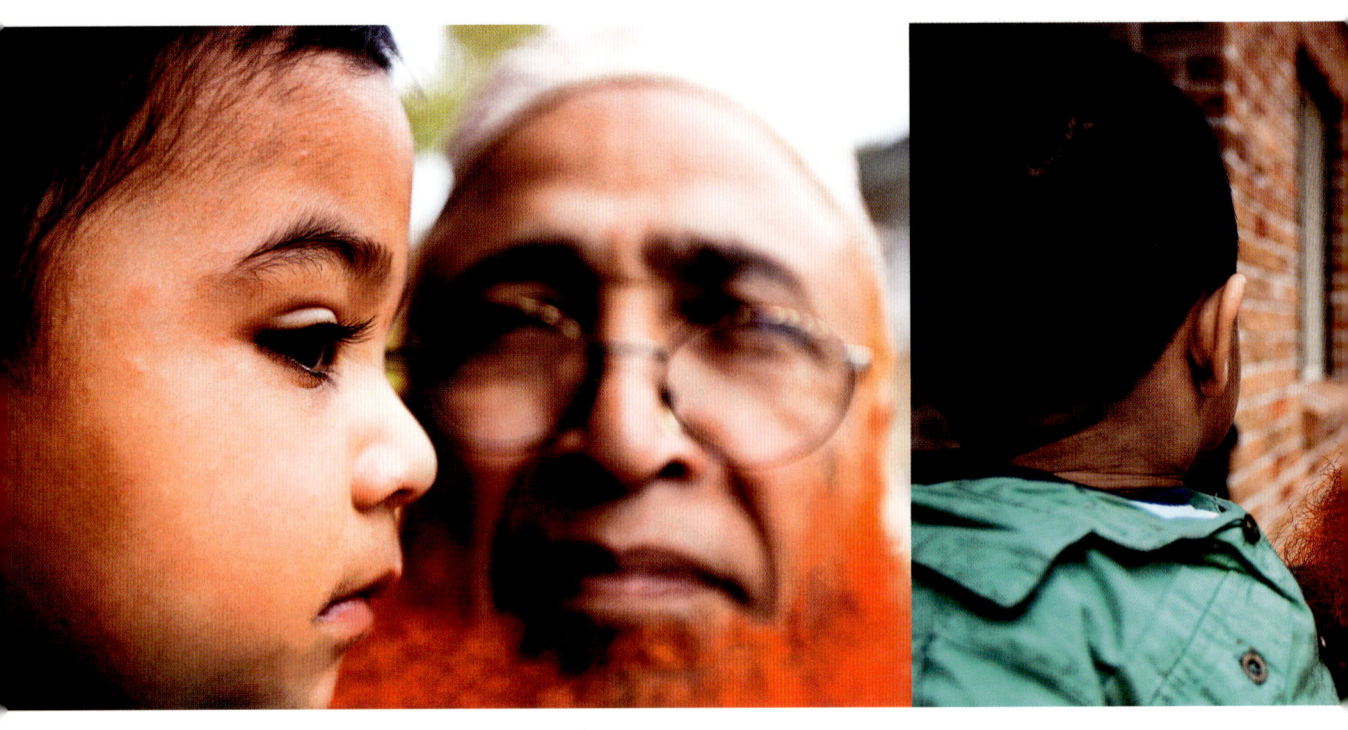

that beard

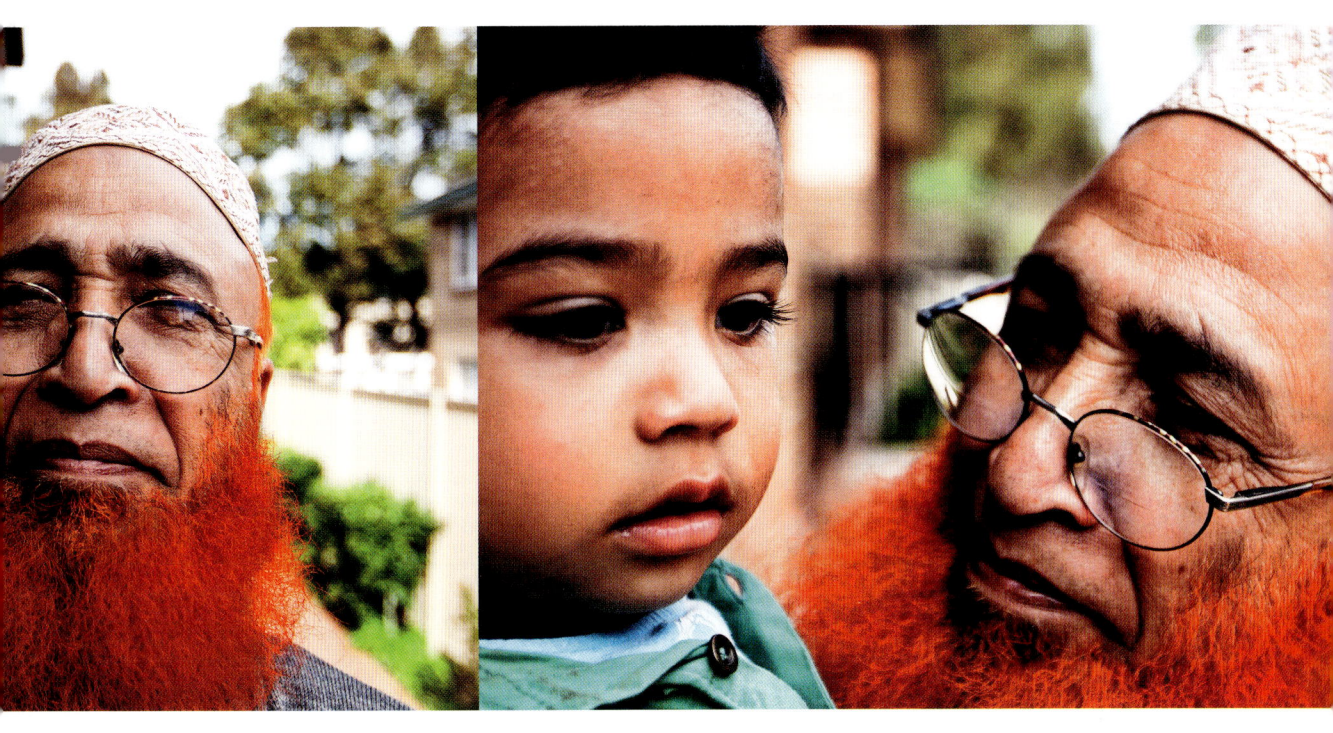

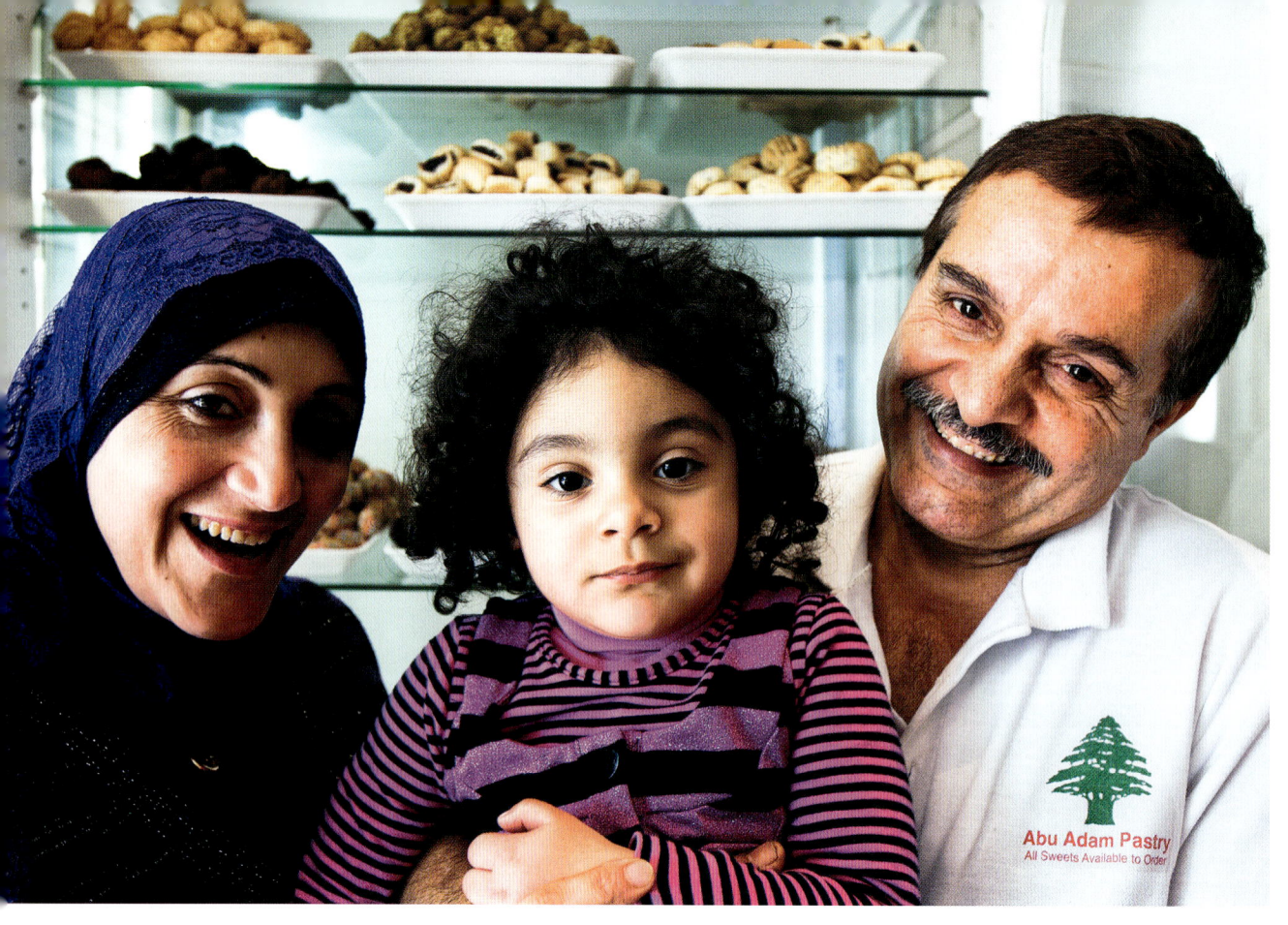

sweet love

painful in any language

potts point

FRIDAY, 18 SEPTEMBER 2009

SEEING AS *52 Suburbs* ventured north and west in weeks one and two, I thought we'd head east this week to the suburb of Potts Point, just three kilometres from the city centre. While I'd driven through Potts Point many times, I'd never dawdled long enough to realise it contains a who's who of buildings from every major architectural period in the last 180 years.

These include grand 1830s mansions, including Rockwall House, Tusculum and Elizabeth Bay House (just down the hill from Potts Point); Victorian terraces along Victoria Street; Art Deco beauties such as Macleay Regis, Manar and Byron Hall; as well as a Streamline Moderne classic, the Minerva (Metro) Theatre.

All in one tiny suburb measuring just one kilometre long by 200 metres wide at its greatest point.

My five-minute research also revealed that Potts Point was named after a bank employee, Joseph Potts, who snaffled up six-and-a-half acres of harbourside land known as Woolloomooloo Hill and promptly renamed it after his good self.

I also discovered that the suburb is home to 'The Yellow House', an experimental art hub in the 1970s, plus Ted Noffs' amazing Wayside Chapel, and that today Potts Point is considered a Paris-meets-Manhattan sort of place, complete with swanky boutiques, gourmet delis and smart bookshops (and a few thousand sailors when the US Navy is in town).

After three hours of happy trawling through the streets, I left the suburb of Potts Point with one parking ticket and hundreds of snaps. A fair swap, I guess.

VERDICT Potts Point is obviously a beautiful suburb with its smorgasbord of architectural delights and not-too-shabby setting. But what I found equally appealing is the mixed crowd that wanders down its many charming streets. The combination of everything made the pain of a parking ticket almost tolerable.

long before the café set moved in

for some

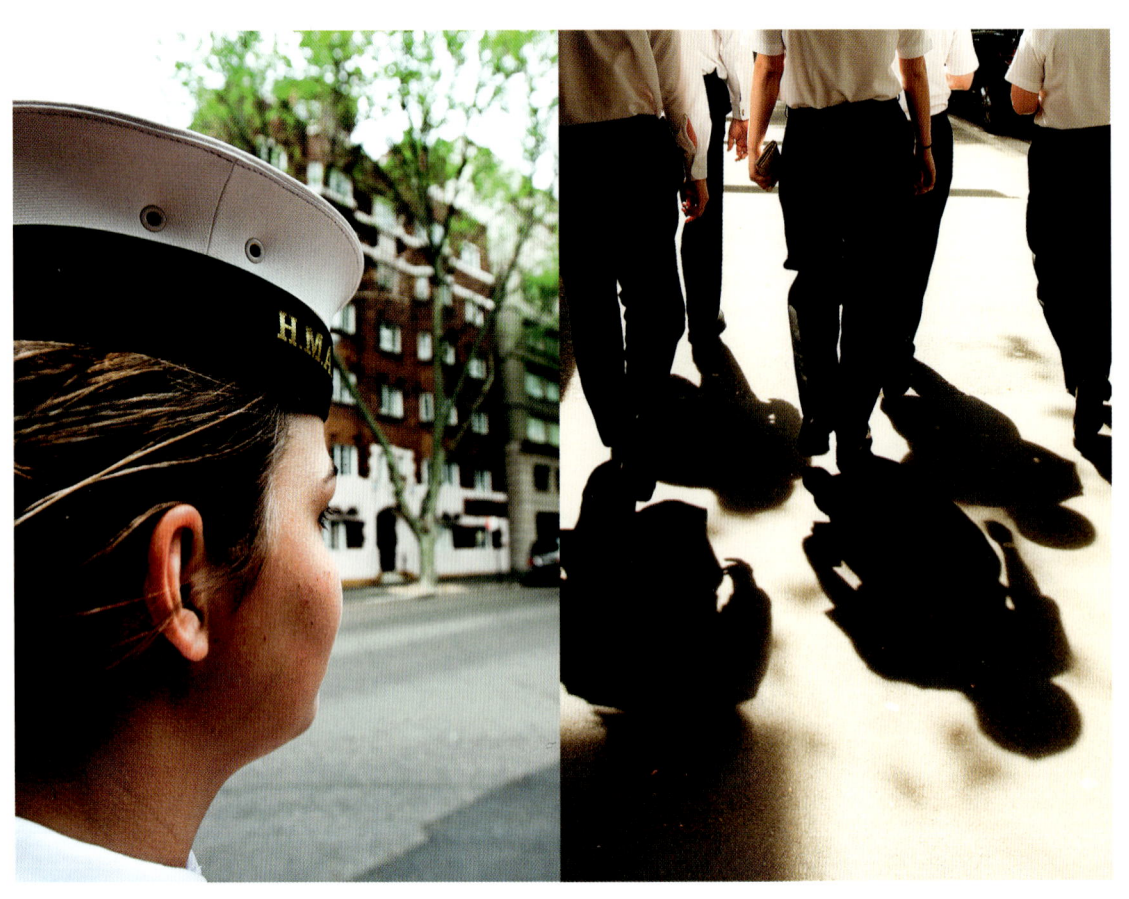

shipshape

chop chop >

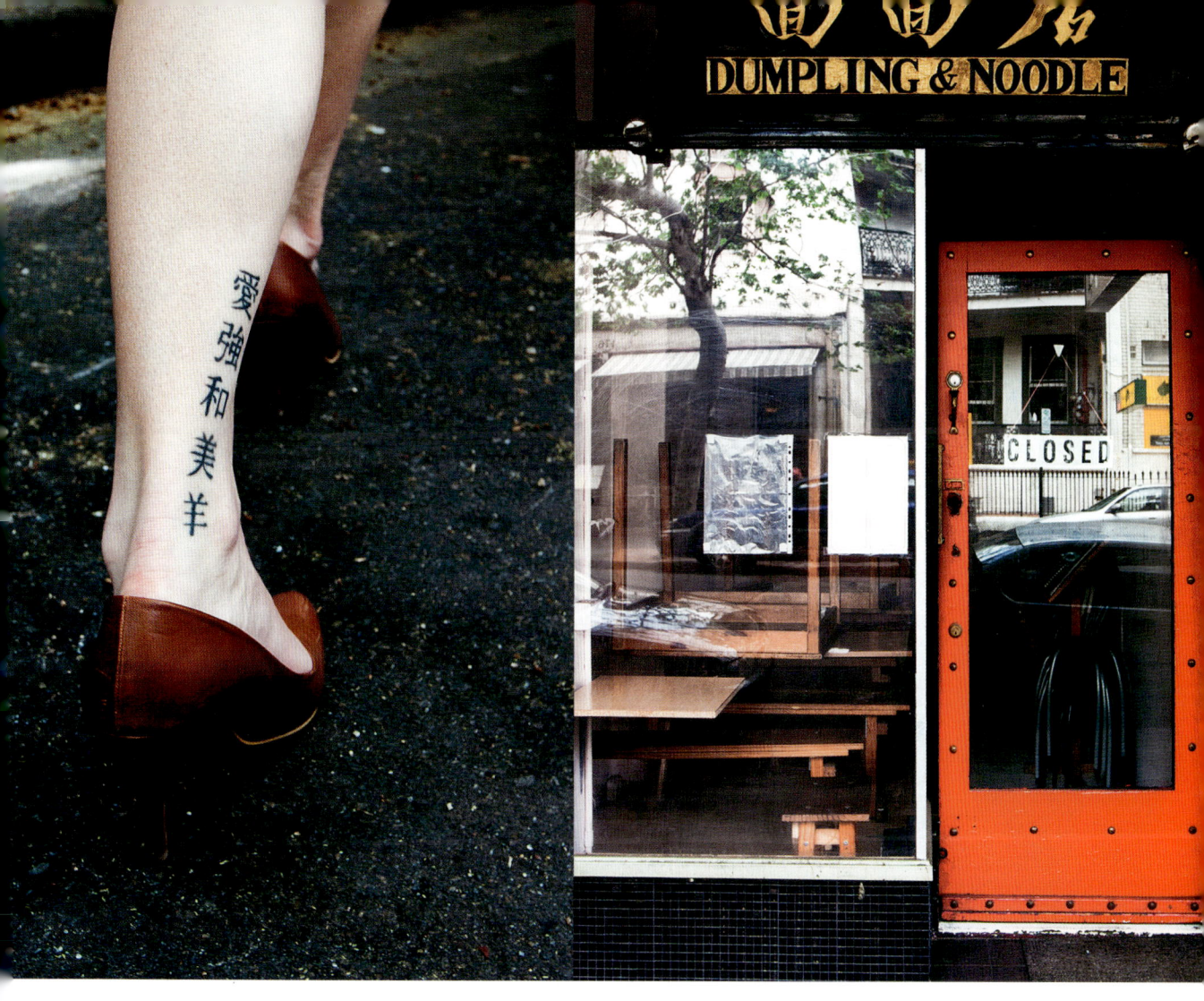

when the world zigs, zag

love blooms >

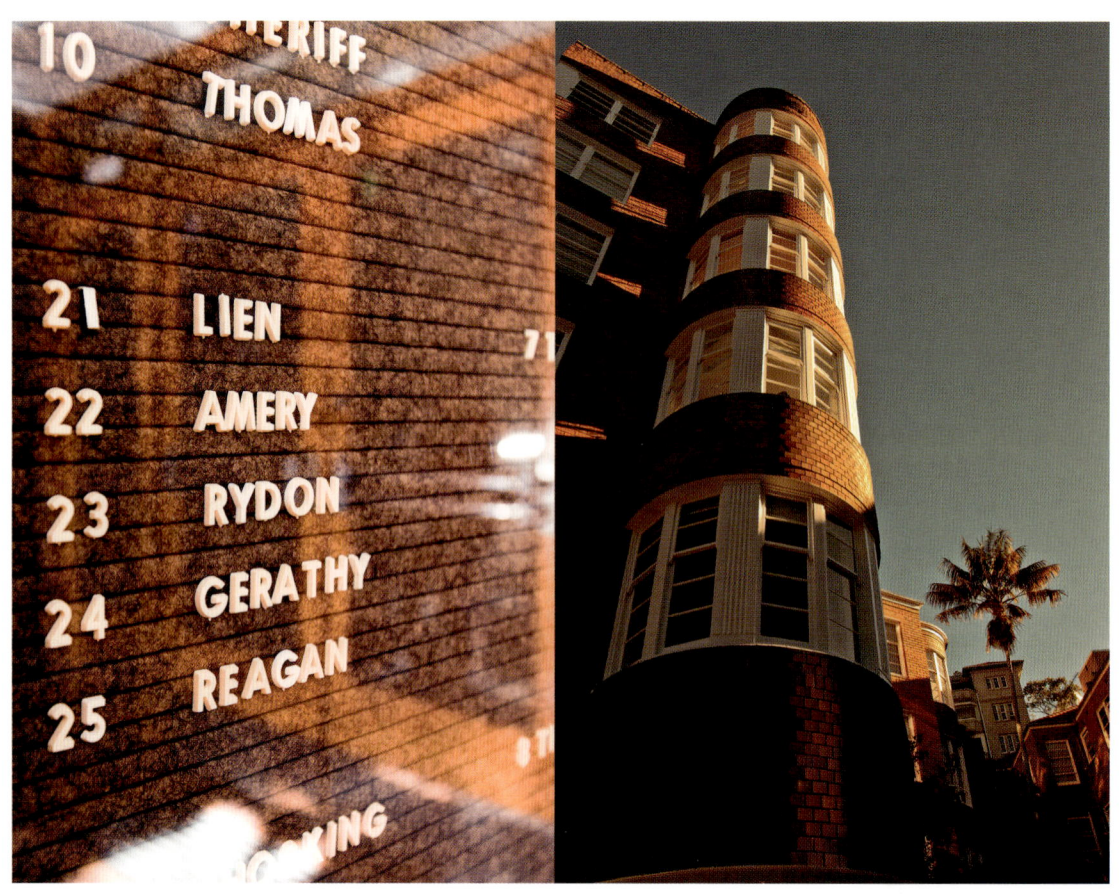

vertical life classic curves >

cronulla

FRIDAY, 25 SEPTEMBER 2009

TO BE FAIR to all points of the compass, *52 Suburbs* headed south this week to the beachside suburb of Cronulla. Again, my lack of knowledge about the suburb was astonishing. The extent of it? A vague memory of a history lesson about Captain Cook and a more vivid recollection of the 2005 riots. Clearly time for a visit – and my usual 'exhaustive' research …

Cronulla is from the Aboriginal word Kurranulla, meaning 'place of pink seashells'. It was the first bit of Australia's eastern coastline to be checked out by Europeans (Captain Cook, 1770). The suburb sits on a peninsula with the longest surf beach in Sydney on one side and a quiet bay on the other. And interestingly or not, Cronulla is the only Sydney beach accessible by train.

On the 40-minute drive down to Cronulla, I was struck by how exciting it always feels just before I arrive in a new suburb. Partly it's the shock of the new – what will I see, who will I meet. (And eek, will I find any 'beauty' to photograph?) But I also realised I find the process of filling in the blanks about my own city and expanding the mental picture I have of it to be quietly thrilling.

Sea Mist

VERDICT Cronulla turned out to be far more naturally beautiful than I'd imagined. I know it's not high season yet but it's also appealingly 'empty' and spacious, especially in comparison to its more northern friends.

As for the built environment, the bits I liked best are those that are fading, peeling and generally disintegrating due to the constant assault by salt and sun. And that foamy, minty, jade-like green. All of which probably drive the locals mad, but there you go.

surf's up

Nippers for big kids

on their last legs

Neighbourhood Watch >

things of stone *in the eyes of some >*

cabramatta

FRIDAY, 2 OCTOBER 2009

THIS WEEK *52 Suburbs* travelled west and east at the same time, to Cabramatta, located 30 kilometres from Sydney's CBD.

Due to certain navigational errors, I had plenty of time pelting back and forth along the M5 to reflect on what I knew about the suburb of 'Cabra' – good Vietnamese food and evil drug gangs. That was it.

Way before lemongrass and crime arrived in Cabra, the Aboriginal Cabrogal people lived there for, oh, 30 000 years. Hence the name – 'Cabra' is Aboriginal for fresh tasty water grub, and 'Matta' is a point or jutting out landmass.

Fast forward to the 1950s and '60s when post-war immigrants from Europe got busy setting up business in the area (like Angelo, the Italian barber and owner of Paris Style Barber Shop, who's been tending to the tresses of Cabra residents for 40 plus years). The Vietnamese, fleeing the Vietnam War, followed them in the '70s, along with refugees from Cambodia and Laos. Many other nationalities were to join them, so that today Cabra is Australia's most multicultural postcode with

120 nationalities and nearly 70% of the population born overseas.

The result is an amazing melting pot, literally; the suburb seems to bubble over with spicy, fragrant Asian food and freshly baked croissants and baguettes, taunting your olfactory nerves at every corner. So I got the food bit right. Not so with the whole scary gang thing. Apparently that was then and this is now and it's all changed and much improved.

Anyway, Cabra is pretty interesting. Worth a visit – or three. That's how many times I ventured out there this week, first to the Moon Festival and then twice more, to snap away and eat and use the five words of Cantonese I know. They laughed. I laughed. Then it was time to go.

VERDICT Did I find beauty? Yes, in the rich traditions and stories of survival, adaptation and integration. In the pastel-coloured fibros that beat the pants off their new brick neighbours towering over them. In the aesthetically pleasing cuisine. And in Angelo's time capsule of a barber shop. Most definitely in the barber shop.

47

moon sparkles

all welcome

Angelo's time capsule

temple and tarts

to help you sleep

eveleigh

FRIDAY, 9 OCTOBER 2009

It's one of those strange things – I lived in Newtown for many years but never once strayed into neighbouring Eveleigh. In my defence, Eveleigh is a smallish suburb, which back then was made up of railway and some big old buildings that looked interesting but were largely inaccessible.

'Research' revealed that while Eveleigh may be small, it has a super-sized history. The Cadigal people lived in the area until the 1790s. In the 1880s, 60 acres of land were devoted to the railways, including those 'big old buildings' on either side of the railway tracks, the Eveleigh Workshops. It was here that the first steam trains in Australia were built, and where railway carriages were made right up until the place was closed in 1989.

In 1991 new life was breathed into the workshops on the Alexandria side of the tracks, transforming them into the Australian Technology Park.

In 2006 it was the turn of the workshops on the Darlington side to be reborn. With the aid of architectural firm Tonkin Zulaikha Greer, the site was transformed into an incredible new performance

space, CarriageWorks, while retaining much of the wonderful old.

Apparently the powers that be have big plans for continuing the suburb's makeover, including new apartments, cafés and shops.

So what did I find? I was lucky enough to visit CarriageWorks during the annual Sydney Children's Festival, when the place comes alive with kids on red cordial and high-velocity circus acts. Entertainment galore for the ghosts of the old workshops.

I also popped my head in on a weekend when the space next to CarriageWorks, the heritage listed Blacksmith Workshop, was bustling with the Eveleigh Artisans' Market. Purchased a few delights and made a mental note to return when the place is given over to the Farmers' Market.

VERDICT There is so much beauty in the massive buildings and rail yards that hold so much history, and still do, thanks to their careful reinvention. To see them filled with new life is just wonderful. May the suburb continue to be reborn in a way that's respectful to all its pasts.

55

skipping girls

my sentiments exactly

bubbling over with joy

where's First?

net

< old rattler

jagged edges

63

castlecrag

FRIDAY, 16 OCTOBER 2009

I have butterflies inside my being as I sit down to write about my visit to Suburb No 7, Castlecrag.

I've visited Castlecrag a few times before this week. But never have I been so bold as to knock on the doors of complete strangers, quickly explain what I'm doing, and ask would you mind, please, if I photographed your iconic home.

So before we crack on, can I say thank you from the bottom of my irrepressibly curious heart, to those kind souls for allowing you and I to have a stickybeak.

What's so amazing about these homes, you ask? Just that they represent one of the most forward-thinking and inspired periods in architectural history.

In the early 1920s American architect Walter Burley Griffin and his wife, Marion Lucy Mahony, set about designing an entire suburb where nature dominated and man-made structures looked as if they grew naturally from the site.

This 'organic architecture' translated into small single-storey houses made out of local stone with flat roofs and

no fences. Only 19 of the 40 houses Griffin designed were ever built, but the principle behind them – the subordination of homes to the landscape – is still highly respected.

The other amazing force in Castlecrag architecture was Hugh Buhrich. Buhrich designed and hand-built two homes in the suburb, 30 years apart. I visited the second one, built between 1968 and 1972, described as 'the finest modern house in Australia' by architect Peter Myers. In many respects it's so Australian – made from organic materials (aside from the red fibreglass bathroom), nestled into but not weighing upon the bush, and filled with light and a sublime view across Middle Harbour, thanks to floor-to-ceiling glass. At the same time, however, it seems absolutely from another planet – or at least another continent (not surprising, perhaps, given that its architect and maker hailed from Europe). My thanks again to the Buhrich family for making the visit possible.

VERDICT Castlecrag has beauty by the bucketload, both in the natural and the man-made. Just the way its architects would have liked it.

No 4

sun on Moon House

sunbursts

reflections

primary colours

when the world was set on fire >

70

harris park

FRIDAY, 23 OCTOBER 2009

HARRIS PARK? Never heard of it before, but when I learnt that the Indian Diwali Festival was being celebrated there, I was suddenly interested in the place, just east of Parramatta and 23 kilometres west of the CBD.

Super quick history lesson this week. The Burramattagal clan of the Dharug people were the first residents in the area. Then came the Europeans and the convicts (James Ruse ring a bell?). Then the Lebanese. Then the Indians.

There's still an Aboriginal presence in the area, and large numbers of Chinese too. But the Lebanese and Indians do seem to dominate.

On my way to find the Hindu temple, I passed by an amazing structure, Our Lady of Lebanon Maronite Church, built in 1972.

Now I realise I'm revealing my ignorance here (nothing new), but I always associate the Lebanese population with Islam. Turns out there's a large Lebanese Christian following too – and this was their church.

I should also mention that there are several historic buildings in Harris Park, all of which I completely ignored. I'm sure they're worth a visit but I was too focused on the fascinating mix of the Indian and Christian Lebanese cultures/religions – in an area so important in Aboriginal history – for anything else to get a look in.

As it was, I only caught the tail end of the Diwali Festival so I can't show you any fireworks or houses lit with 'diyas', tiny clay-pot candles. But I can tell you that while the Diwali Festival is popularly known as the 'Festival of Lights', its most significant spiritual meaning is 'the awareness of the inner light'. Isn't that what all religions are about, at their core?

I left Harris Park laden with Indian sweets, new knowledge, and a camera full of holy crosses, Aboriginal art and saris ...

VERDICT So much beauty in the mix and such obvious passion for their respective religions and cultures. But you can feel the tension. A microcosm of the world right there in Harris Park.

borrowed land :: 1

borrowed land :: 2

< *the light of all religions*

bright spirit

yum

blacktown

FRIDAY, 30 OCTOBER 2009

WHAT DID I know about Blacktown before I ventured out there this week? Only that a *52 Suburbs* follower kindly suggested I visit it for a 'real challenge'.

The weather was testing me too – at the very least a clear blue sky would offer some colour, some interest. But no, just grey blandness everywhere in Sydney this week.

As I rocketed along the M4 in search of a suburb named without a colour, under an equally monotone sky, I felt sure I was doomed.

The facts. Dharug until the 1790s. Governor Macquarie, more pro-Aboriginal than his mates, established Blacks' Town in 1821 and granted land to two Indigenous men. In 1862 the suburb became known as

Blacktown. It was semi-rural until it took off in the 1950s when the railway line was electrified. Blacktown still has the largest Aboriginal population in New South Wales, as well as immigrants from the Philippines, India and Africa.

There are some historic buildings dotted around in nearby suburbs. But in Blacktown itself there are only

two: a former school that's now the Visitor & Heritage Centre and an old church, now home to the Blacktown Arts Centre.

How was it? I won't lie. It was pretty tough going. At one stage I was more interested in what to have for lunch than what to photograph. But then something happened. Lured to a public hall in the centre of town by the smells of spicy food, I chanced upon the Community Expo 09.

Bollywood dancers at one moment, didgeridoo the next. I met Africans from Sierra Leone, Sudan, the Congo and Liberia. An Afro-Brazilian. And Martin, skin name Jupurula, the Aboriginal didg player. Blacktown may be faded, but its people are more vibrant and colourful than ever.

VERDICT Blacktown isn't blessed with beauty of a natural or built variety. But there's a lot that's appealing about a suburb that can accommodate vastly different cultures and traditions, providing much-needed sanctuary from less tolerant societies. To my eyes Blacktown represents hope and is full of life and colour – you just have to search for it.

skin deep

from Sudan to Sydney

eventually he cracked

row upon row

lace and roses

auburn

FRIDAY, 6 NOVEMBER 2009

WELCOME TO the 'Turkish capital of Sydney', Auburn. Also home to Chinese, Vietnamese, Lebanese, Somalian, Indian, Pakistani, Afghan – and a large population of peafowl (peacocks being the male of the species).

The incredible cultural diversity is certainly interesting, but what really struck me was the little piece of Istanbul in the middle of Sydney suburbia, in the shape of the Auburn Gallipoli Mosque, and a large chunk of green in the form of the Auburn Botanic Gardens.

I did know about the mosque before I arrived and even organised a tour of the place days in advance. But I still wasn't prepared for the sight of towering minarets just off Parramatta Road.

But what was possibly even more surprising was stumbling on the Auburn Botanic Gardens. I went on a weekday, when a gentle mist of rain was falling. Not a single bod around but me to absorb the beauty of a Japanese Zen garden and a whole lot of freely wandering, feather-shaking peacocks. You could hear a pin drop yet I was a stone's throw from the bone-shaking highway.

The main street of Auburn is all about great Turkish and Lebanese food. But as tasty and vibrant as it is, I did get an insight into what Auburn was like for older Anglo residents when I met a woman who'd lived all her life here. She'd seen it transform from middle-class 'white Aussies' to the multicultural melting pot it is now. While she had many Lebanese friends and didn't have any problems with different cultures, she felt a loss of identity – there weren't many of 'her' left.

Some history. Arthur Phillip, the first governor of the colony, and John Hunter, his successor, came across the area after a trip up the Parramatta River. Named after an English village, Auburn was settled in 1806 and divvied up in 1823 among a mix of free settlers and convicts.

The 'burb took off in 1877 when the railway came to town and the land was subdivided and sold off. Auburn became an industrial centre with a carriage works and engineering focus.

VERDICT Auburn has loads of beauty – in the gardens, the mosque, the people. And in the little bits of faded suburbia that are just hanging in there.

pencil and books

caps >

91

No 9

rust and lace

open for business *one and all >*

Jewish community developed after World War II and still continues to dominate the area, hence the presence of a couple of synagogues, a kosher butcher and, until very recently, the Hakoah Club.

Although the one-kilometre beach is world famous, the water quality was a bit suss for a long time thanks to an untreated sewage outlet; thankfully all that changed in the mid-1990s when a deep ocean outfall was completed. Today Bondi is packed to the gunnels with everyone from tourists and backpackers to young families who can afford the real estate, and TV crews shooting yet another lifesaver/vet/drama series.

VERDICT Bondi has its less-than-beautiful side but its cliffs and their current visitors – of the sculpture variety – are pretty special.

nests

what a whirl >

95

96

103

you star

< *Arabic to Zen* *green*

97

the Imam and the faithful

rose Turkish Delight, before and after

bondi

FRIDAY, 13 NOVEMBER 2009

BONDI? NOT exactly off the beaten track or undiscovered, I know. I had planned to go north, a lot further north than Australia's most famous beach. So what happened? I took a look at the Sculptures by the Sea exhibition that currently snakes around Bondi's coastline and decided I really needed to possess it, in a photographic sense. I didn't have the time to do that and a separate *52 Suburbs* post, so I decided to break my own rules and focus on a suburb I know only too well.

But this is not Bondi as glamour scene. This is the Bondi that happens just once a year, when thousands descend on the suburb to gawk at sculptured art rather than chiselled bodies with buns of steel.

My take on it? To find a 'partner' image from everyday, ordinary Bondi to keep their more highfalutin sculptural friends company out there on the lonely windswept headland.

But before we begin, a little background to the 'burb. Bondi is Aboriginal for 'sound of waves breaking on the beach' or 'noise of water breaking over rocks'. A big

sculpture, of the everyday and the extraordinary

hanging around

it's not that black and white

108

aqua world

domestic life

surfing the tube

marrickville

FRIDAY, 27 NOVEMBER 2009

I HAVE BEEN itching to explore Marrickville, seven kilometres south-west of the CBD, ever since a regular follower of *52 Suburbs* suggested it. I've been before, many times, but only to visit friends at their homes. Never once have I walked down the main street, only ever driving through it, impatient to get to where I was going. So when I hopped out of my car this week with a reason – an excuse – to stick my nose into churches, homes and people's faces, I felt as if I was visiting an entirely new suburb.

Some history before we wander. Cadigal out, British in. Land grants were handed out to begin with and then various rich dudes bought the land from the grantees.

One such man, Thomas Holt, who already owned various chunks of Sydney, snaffled up 100 acres, built a mansion and bred rabbits for hunting, hence the name of the estate, The Warren. Industry-wise, the area was part market garden, part industrial, with soap and candle factories, three brickyards and a tannery. The first school opened in 1864, the post office

in 1865 and the railway line to Bankstown in 1895. It was named after a local estate called Marrick, which was in turn named after a village in Yorkshire, England. The 'ville' bit was added later.

VERDICT Marrickville seems to have a little of everything. A mix of industrial, residential and commercial. People from all over the planet. A great big old river. Churches of every description. A couple of social clubs and a place you can save a mannequin or a piano from the scrap heap. Not to mention some of the finest examples of chipped ceramic tiles and rusty garden gates *52 Suburb*s has seen so far. No wonder everyone from Newtown seems to be moving there.

ladies of the lawn

feed the soul

< i see bananas in your winged dragon

i'm a fan

does he change hats when he goes back to work on the building site?

Chinese herbs – the secret to longevity?

bankstown

FRIDAY, 4 DECEMBER 2009

MY KNOWLEDGE of Bankstown, 20 kilometres south-west of the CBD, prior to this week? Shamefully almost zilch. What I did know, however, was that it had an airport. And airports have planes. Which is why this week *52 Suburbs* was able to take to the skies for a different perspective on life in a Sydney suburb.

Established during World War II as a key strategic air base, Bankstown Airport today is a sprawling 313-hectare site with three runways and a whole load of businesses – including a handful of fixed-wing and helicopter flying schools.

Among them is the Red Baron, and with the help of the lovely Joel, my camera and I were lifted heavenward in a plane that looked like it came straight out of a storybook – a bright red open-cockpit biplane. Joel did a quick pre-flight test, slapped a most unflattering Teletubbies-type cap on me, and next thing I knew we were sailing into the ether. The cockpit is open so you're feeling the same wind rushing past you as the birds. I had to remind myself to take pictures because you could so easily switch off

120

and lose yourself in the feeling of being so free. Fortunately I managed to keep snapping.

Some history of the broader suburb before we take off. The Bediagal people enjoyed thousands of years living in the heavily forested area until two explorers, Matthew Flinders and George Bass, stumbled across it in 1795. Governor Hunter made it a pioneer colony and called the place Banks' Town in honour of botanist whiz Sir Joseph Banks. It took off after 1926 following the electrification of the railway, and today this once rural, isolated backwater is now thoroughly suburban and one of the most multicultural areas in the country, dominated by Vietnamese, Chinese and Lebanese.

VERDICT Beauty in Bankstown? The surrounds are blessed with swathes of unexpected green, the Georges River National Park. And the suburb itself has the same appealing colourful energy that so many multicultural Sydney suburbs have. But for me the high point was most definitely in the heavens above.

would madam like her cockpit open or closed?

lady in red >

123

< aerial view

roger Red Baron, you are cleared for landing

what happens if i push the CRASH button?

anyone for chicken feet? >

haberfield

FRIDAY, 11 DECEMBER 2009

HABERFIELD, NINE kilometres west of the CBD. Been there a few times before but, like Marrickville, only to visit friends. My entire experience of the main street was limited to finding a bottle shop to buy some wine for said friends. Hopeless, really. But even with eyes half shut it was impossible not to notice there was something different about the suburb – namely the gardens were big and the houses consistently attractive and mainly Federation. So it didn't come as a surprise when I learnt this week that Haberfield was designed as a 'model' garden suburb and that the entire suburb is heritage listed, hence the uniform appearance.

Some history to kick off with. The Dharug people were first in, to be replaced by the British, two of whom – David Ramsay and Richard Stanton – made their mark on the place. The Ramsay family built a great old building, Yasmar, and St David's Church. Stanton arrived in the early 1900s to name the suburb after some English rellies and transform the place into a garden suburb. The Italians moved in a little later and never left.

Random impressions: quiet, nice churches, very green and flower-colourful. Yasmar is kind of spooky now that it's all shuttered up. And there's a small but lethal cluster of Italian restaurants, cake shops and delis on Ramsay Street – I am now much wiser about the suburb but considerably fatter too.

VERDICT The 'model suburb' of Haberfield was designed to be beautiful, and it is – what it lacks in diversity it makes up for with uniformity in its homes and gardens. Even the food is aesthetically pleasing, with pretty pastel-coloured gelatos and delicate Italian biscuits. So pleasing I ate half the suburb before I rolled down to my car and left. Stuffed, but happy to be one more suburb slightly wiser about my own city.

the greengrocer's dad

a garden suburb

< spooky Yasmar ice-cream in the tiles

133

< *fairies in the garden* *flowers everywhere*

pyrmont

SUNDAY, 20 DECEMBER 2009

ASIDE FROM being busy with Christmas hoo-ha, I was stuck in Pyrmont all week working. So the only way I could squeeze in *52 Suburbs* was to make Pyrmont 'burb No 15.

I'm so glad I did – it made my head spin on so many levels. Massive old factory buildings, rows of small terraces and a handful of derelict buildings rub shoulders with the ultra-modern high-rise apartments of Jacksons Landing. Here and there you are reminded of the history – the CSR sugar refinery, the woolstores, sandstone quarries and powerhouses. It's not hard to imagine tiny St Bede's Church disliking its brash new neighbour, Star City Casino, the site of a former power station. And the waterfront wharves, once the domain of the tough as guts, are now filled by young urbans with soft hands. Then there are the unexpected, wonderful parks, the harbour and that beautiful bridge dedicated to the brave, the Anzac Bridge.

Some history before we amble. Pyrmont got its name in 1806 when a lady at a bush picnic in the area noticed a spring of cold water

bubbling out of a rock; she suggested the place should be called Pyrmont after a popular natural spa by the same name in Germany.

Pyrmont was a working-class industrial and port community for a long time but by the early 1990s the suburb was in a bad way, underpopulated and largely derelict. The government encouraged both people and business to return, and today the suburb is an interesting, vibrant mix of commercial and residential.

Much of Pyrmont has been redistributed throughout Sydney thanks to the massive quarries in the suburb that provided sandstone for many of the city's 19th-century buildings.

VERDICT Pyrmont's beauty is of the fascinating, successful facelift variety. I just hope they don't get rid of any more wrinkles or the place might start looking unrecognisable.

Pyrmont is on a peninsula

A is for Anzac Bridge

and the 1874 James Craig

Doreen, in Pyrmont since 1925

sharp angles

semi-industrial feel

derelict, not

clovelly

FRIDAY, 1 JANUARY 2010

OKAY, SO this is a little odd. Not just that because of Christmas and lack of time, this week's suburb is my own. What's really odd is that I should know my own suburb like the back of my hand, right? What I discovered is that I don't – not really.

I've lived in Clovelly for almost three years but until this week I'd never once stuck my nose inside the spectacularly sited bowlo. Never peered into Clovelly Bay long enough to notice how truly beautiful the patterns are. Never walked slowly enough through the neighbouring cemetery to appreciate how old and sad some of the graves are.

Who doesn't know their own suburb?! Sure, I've been busy these last few years but when I thought about it I realised this is the clearest example of the way people can walk around with eyes half shut, not really alive to it all – even in one's own blooming suburb. Which is exactly why I started *52 Suburbs* and why I'm so relieved to have found a reason – an excuse – to get out of my own head and move through the world. Slowly. Taking the time to really look.

Anyway, to 'Cloey', a smallish beach-side suburb squeezed in between its possibly better known neighbours, Bronte and Coogee.

Some history. Named Little Coogee until 1913 when it was changed to Clovelly after the village of Clovelly on the north Devon coast of England. One lucky William C. Greville bought 20 acres, including the whole bay frontage, for 40 pounds in 1834.

Long-time locals told me that Cloey was once a poor suburb with the local school filled with kids in bare feet. Things are a little different nowadays, but there are enough 'average' families and shabby apartment blocks to stop it putting on too many airs and graces.

VERDICT Beauty? By the sand-bucket load. Largely because of its bay but also because Cloey's not all tarted up and has remained relaxed and unpretentious. And can I just say, I'm so glad I visited my own suburb – if it wasn't for *52 Suburbs*, who knows how long it might have taken me to get to the bowlo?

fly free

long lines of early morning >

149

nice corners of the world

build muscles or buy them

all stand for God Save the Queen

the inspiration? >

surry hills

MONDAY, 4 JANUARY 2010

THE FIRST suburb in 2010 had to be the one that bears the very same postcode – Surry Hills, 2010. Which was handy because Surry Hills is relatively close to home and there's been no time to roam far these past few weeks.

My five-minute research revealed Surry Hills, which is a stone's throw from the CBD, to have endured a roller-coaster ride over the past 200 years. In short, it goes something like this: Cadigal kicked out in the 1790s; British farmed the land; population explosion; crime-ridden slum; reborn by post-war migrant influx; gentrification from 1960s to today. Nowadays Surry Hills is a vibrant suburb filled with restaurants, pubs, art galleries and the rag trade.

I've been many times before over the years but as with suburbs like Haberfield and Pyrmont, I've never really wandered the streets for hours on end, just for the sake of looking. I left with a much greater appreciation of Surry Hills' history as well as its present-day incarnation as a wonderfully colourful corner of the city. Oh, and the name? After the Surrey Hills in Surrey, England.

VERDICT The beauty for me in Surry Hills is in the way its tangled streets and lanes remain true to their history, peppered with handsome beauties that have seen better days but still stand tall. The street art that enlivens otherwise characterless walls. And the mix of residents, from seasoned old-timers to fresh-faced young hopefuls.

< red flower girl

Ruby red

urban jungle

web

or maybe not

stick 'em up sister

please ring bell here

day of rest >

163

ingleside

MONDAY, 11 JANUARY 2010

WHEN I told friends I was 'doing' Ingleside, they either stared at me blankly or thought I was talking about Ingleburn, a suburb south of the city centre.

Whilst I at least knew it was north, I couldn't have told you exactly where north. In fact, it ended up being Suburb No 18 only by accident. After talking to a friend about the Bahá'í religion, I became curious about it. I remembered the Bahá'í temple was on the Northern Beaches, and when I studied the street directory I discovered the temple was in a suburb called Ingleside. What happens in Ingleside, I wondered? Suburb No 18 decided.

As it turns out, not a lot happens in Ingleside. But what is amazing is how rural it is. One minute you're driving along busy roads and the next you're in the bush. You see horses but not people. Road signs warning you to watch out for 'Dragons'. And driveways the length of small roads leading to – you can only assume because you can't see them – houses.

164

It's just not something you expect to find a mere stone's throw from the ocean and 28 kilometres from the city centre. So it didn't come as any surprise to read that Ingleside's days as a low-density suburb may be numbered as there are plans to populate the area. All the more reason to 'document' the place while it's still a breath of fresh air and a little bit of country by the sea.

By the way, the suburb is named after a mansion in the area called Ingleside House, built in the 1880s by a baron, no less. Baron Von Beirenm was an industrial chemist who ran a gunpowder and explosives factory in sleepy old Ingleside – hence the naming of Powder Works Road.

VERDICT Ingleside is beautiful in its quiet and isolation. And horses being my favourite animals just made it all the more magical. Despite the fact most of us city dwellers live like sardines and you can see the need for more housing in Sydney, I secretly hope Ingleside remains the domain of the equine, the duck and the dragon.

< all roads lead to heaven

the different sides of Ingleside

< *nine is the magical number* *i see stars*

bend

heavenly light

lidcombe

MONDAY, 18 JANUARY 2010

LIKE MANY people I find religious buildings of any persuasion to be visual feasts. But not being religious myself I'm also intrigued by both the power of faith and all the ceremony involved.

So when I discovered that Lidcombe's cup runneth over with churches – three of which looked like they'd been transported from exotic lands far away – I was tickled pink. So much so I decided to do something I never do – put on a nice frock and go to church.

How was it? Well, it's a foreign experience for me at the best of times. But I really felt like a fish out of water in these churches, two from Eastern Europe and one from the Middle East.

What I didn't know about Lidcombe was that it also has one of the most delightfully retro swimming pools I've ever seen. It was such a thrill to stumble on it and see kids from backgrounds as mixed as the pool's multicoloured tiles enjoying the aquatic life. If I'd had my swimmers I would have had a splash myself.

Lidcombe History in brief: Dharug people 'moved on' by European settlers; industry boomed towards the end of the 19th century – a mix of abattoir, engineering and funereal; then manufacturing; Irish replaced by Europeans, who were joined by Asian and Middle Eastern. Today, Lidcombe is a mix of Ukrainian, Korean, Nepalese, Chinese, Turkish, Russian, Syrian, Lebanese and Palestinian.

Given this extreme mix, it's not surprising that nearby Rookwood Cemetery is the largest multi-cultural necropolis in the Southern Hemisphere. I popped my head in, but as much as I like a good cemetery, I didn't dally, the tragedy of Haiti swirling in my mind, the tens of thousands who won't rest in peace in a proper grave.

VERDICT I did find beauty in the 'burb of Lidcombe – the churches and the zany pool were highlights. But you can't help thinking, as you walk around an almost deserted town centre, that it has suffered greatly from the draw of larger shopping centres and seems almost too quiet. Especially given how close it is to that deadly silent, super-sized cemetery.

different religions

onion domes

motherly love

timeless

multicolourful

Korean petal

through a veil

spots and stars

newtown

SUNDAY, 24 JANUARY 2010

AFTER THE muted tones of Lidcombe I needed a burst of colour and movement and decided to visit Newtown, just four kilometres from the CBD in Sydney's inner west. Or revisit, I should say, having lived there in 1990 for four years and been back many times since. But how well did I really know it?

At a glance it seems the same. But when you look closer you notice the evolution. More gloss, less edge. More prams, less goths. Previously slightly dodgy pubs renamed and renovated, now patronised by those that 15 years ago wouldn't have dreamed of setting foot in the place.

But King Street still streams with life and my regular haunts are still there, looking a little older like me but pretty much the same. Carlisle Castle, Kuleto's, The Sando, The Hub, Gould's Bookshop.

Some of the best and worst times of my life happened while I was living in Newtown. So as well as the hit of colour and movement I was craving, I also found myself on a bittersweet walk down memory lane.

But just as I'd start to reminisce, I'd run into another larger-than-life character who would yank me back to the present. It seemed to me that while the suburb may have lost some of its colour, it still attracts the colourful and offbeat as well as the much-maligned 'yuppies' and their 'designer babies'.

I left feeling like I'd just scratched the surface, wondering about all the other stories playing out in Newtown's hundreds of tiny terraces.

Some history. Cadigal until Newtown formed in 1862, a suburb of 200 houses. Named after a local grocery store. King Street is still Australia's longest continuous shopping strip with an eclectic mix of mid-Victorian, Federation and 20th-century architecture – some lovingly cared for, some left to age gracefully.

VERDICT Is there beauty in Newtown? Yes, if you're prepared to raise your gaze from street level to the many lovely old facades. Or look closely at the crowds, to find the bright sparks that live a more colourful life than many.

women in uniform

thank goodness I have no eyeballs to see what girls wear nowadays >

< *King Street melts in summer*

living art

red heads

all the world's a stage

brighton-le-sands

MONDAY, 1 FEBRUARY 2010

OVER THE years I've driven through Brighton-Le-Sands many times on my way down to the South Coast for weekends. Not that I actually knew it was Brighton (as the locals call it). I just knew it as the place you drove through with a huge bay on one side and a small clump of restaurants and shops on the other. And on the way back home late Sunday night it was all go with people spilling out of packed gelato bars and young hoons spinning their wheels.

So I was interested to see how much more there was to the suburb, located 13 kilometres south of the CBD, when you actually explored it.

To start with it was a little grim. The big white hotel, looking grey and tired, towers over a main street filled with places to eat and not much else. But as soon as you cross the main road towards Botany Bay, a kind of magical world unfolds.

Nothing but miles of blindingly white sand and a huge expanse of water and sky. Well, nothing except for a major airport's runways to your left, perfect for people like me who could watch planes soaring heavenward all

day long. Or the twinkling lights of faraway industry straight ahead. Or a bunch of kitesurfers to your right, gleefully gunning along, pausing every so often to rise up effortlessly or spin around in a mid-air somersault.

Some facts. The First Fleet arrived in Botany Bay in 1788. The area took off when the railway opened in 1884 and swimming baths and a racecourse were built. Today Brighton is a mix of residential and retail with a population of Greek, Lebanese, Egyptian and Chinese. If you're not into plane watching or kitesurfing, you can always have a dip in the shark-netted enclosure, once the site of the Brighton Baths that were destroyed by a freak storm in 1966. The suburb is named after Brighton in England with the Le-Sands bit added later to avoid confusion.

VERDICT Is there beauty in Brighton? I enjoyed the little bits of old suburbia here and there, but mostly I loved the bay with its energetic mix of the natural, aeronautical and industrial. A fine place to sit and ponder what it's all about.

a seagull's worst nightmare – sky or mirrored glass?

the big blue and little red

United Colours of Soccer

soccer goal net? >

yellow poles

Belinda thought the puffy flowers looked like hairy lanterns

circles and dots

rockin' the suburb

glebe

MONDAY, 8 FEBRUARY 2010

HAVING STARTED my walk down memory lane with Newtown, I thought I may as well finish it by revisiting the suburb I lived in when I first left home – Glebe (or The Glebe if you want to be pernickety about it).

And it has been raining cats and dogs of late, as every slightly damp and musty-smelling Sydneysider will attest. Which made me think – do I really want to drive for an hour to a faraway suburb to be greeted with sheets of unfriendly-to-camera rain?

So Glebe. 19 years old, I shared a flat with my lovely friend Fiona above the newsagency on St Johns Road and worked at the Pudding Shop and Habit Wine Bar (now the Different Drummer). Somehow, in between the waitressing and the many gorgeous boys I befriended, I studied law at Sydney Uni (if ever someone spent three years of their life studying the completely wrong subject, it was me).

Random things I remember: cheap rent, lots of students. Hippie and herbal. Vocal feminists. You went to the Valhalla but not the Toxteth. Café Troppo. Gleebooks. Badde Manors. The markets. The Harold Park Hotel.

Much has changed. The first thing the locals mention is that the 'yuppies' have taken over. But what they get really hot under the collar about is the demise of two much loved 'institutions': the Valhalla, an art-house cinema (now offices), and Blackwattle Studios (now apartments).

Some history. The Wangal people booted out in the 1780s to make way for a 'glebe' (church-owned land). Later became heavily industrial (timber, manufacturing) and blue-collar. Gentrified in the late 20th century and now a mix of amazing old mansions, more modest terraces, a pocket of Housing Commission and a handful of newish apartment complexes. The suburb also has one of the highest Aboriginal populations in Sydney.

VERDICT Beauty? Yes, in the lovely old homes and the even older trees down at the park. And in the way that, despite the obvious changes, there are still enough remnants and reminders of the past to make the present that much richer.

would a chai latte help?

i see a bridge in your shoes

old and new playgrounds

maybe these clothes once watched the races

not long for this world

repeating patterns >

207

feral yet refined

the yuppie and the young ones

eastwood

TUESDAY, 16 FEBRUARY 2010

23

AFTER MY recent forays into suburbs that are arguably more urban than suburban, it was time to lose myself in deep suburbia. It had been a while since I'd cursed my lack of navigational expertise or fretted over fuel consumption. And I wanted to drive far enough away from the city's gravitational pull to somewhere you could feel time stand still and hear the hum of nothingness.

So I chose the northern suburb of Eastwood. Mid-Chinese New Year celebrations. So much for the hum of nothingness – you could barely hear yourself think above the din of the lion dances, especially when they danced through the supermarkets to get rid of any evil spirits lurking in the aisles.

This once Anglo suburb is now home to a thriving Chinese and Korean community, who frequent the many Asian eateries and Asian shops and follow a calendar full of Asian celebrations. So much for deep suburbia.

Some history before we look. Located 17 kilometres north-west of the CBD, the first inhabitants were the Wallumattagal people who lived between the Lane Cove and Parramatta Rivers. Between 1790 and 1803 the area was granted to marines of the New South Wales Corps. An Irish free settler, William Rutledge, named the suburb Eastwood, presumably because the area was heavily timbered. And presumably some of those trees were apple trees because it was here that the first Granny Smith apple was first grown.

VERDICT I didn't really snap any examples of Eastwood's Federation homes, but there are some good ones. I think I was too seduced by those crazy loud lion dancers, ridding the suburb of its ghosts, one supermarket at a time.

211

long-time residents and more recent arrivals

dotty about dumplings

classic symbols

rosebud lips

frills and flounces

216

Lisee for me

the passing and the permanent

liverpool

MONDAY, 22 FEBRUARY 2010

24

LAST WEEK I decided to go 'deep into suburbia' and visit Eastwood. As one follower of the blog kindly pointed out, Eastwood is just 17 kilometres from the city centre – hardly in the bosom of suburbia. So this week I was determined to double the distance and ended up in Liverpool, 32 kilometres south-west of the CBD.

I'd never been to 'Livo' before so I did my usual in-depth five-second research. In 1810 Indigenous Australians were given the boot to make way for Governor Macquarie to create a town. He named it after the Earl of Liverpool, the Secretary of State for the Colonies. With the help of convict architect Francis Greenway, Macquarie built some fine things and turned the surrounds into a major agricultural centre. The market gardens and chook farms thrived until the 1950s when the area filled up with working-class families and huge housing commission estates. Today, Liverpool is a major city centre and very multicultural, including Lebanese, Indian and Eastern European.

Of all the suburbs I've visited so far, Liverpool reminded me most of the Sydney I remember as a child. I'm not sure why exactly – maybe something about the grid-like layout of the suburb – but it felt like my memory was being tugged and prodded at every turn. It was the sort of place my nan would take me for a milkshake and a bag of coloured popcorn. High livin' indeed.

It was when I popped into Casula Powerhouse, five minutes down the road, that I really had my memory tugged. Decades ago my architect friend, Julie Mackenzie from Tonkin Zulaikha Greer, had been involved in turning the powerhouse into an art space and we all made the trek out there for the opening. My more mature self appreciated it even more, a great example of adaptive reuse.

VERDICT The impressive buildings *are* impressive. But as usual I loved the low-key and the uncelebrated. The 'continental supermarket', an Indian sweet shop and the barber that have been around for 20 plus years and are still managing to survive despite the Westfield invasion up the other end of town. Give me chipped tiles, peeling paint and wonky sign-writing any day.

warm smile, cold cuts

take a seat

fashion of the day

god's light, no matter which god >

225

stilts

winding staircase

from one continent to another

the Livo Boyz >

randwick

TUESDAY, 2 MARCH 2010

AFTER A dip in my energy levels last week, I decided to make it a little easier this week by choosing a suburb close to home – Randwick.

I've driven through and to Randwick countless times before but never once explored it. In just a few days of nosing around the place, I discovered more about it than I have over the last three years. Astounding.

That said, I would have seen even more had one event not distracted me for almost half the time I spent in the suburb – the world's first gay and lesbian race day. I had no idea it was on. I just thought I'd check out Randwick Racecourse. When I looked up the details, there it was, the inaugural Pink Stiletto Day.

A brief history of the suburb, located six kilometres from the city centre, goes something like this. Cadigal out, English in. The latter whacked up a Captain Cook memorial and proclaimed the place Randwick after a village in Gloucestershire, the birthplace of Simeon Henry Pearce, Mayor of Randwick six times over.

Architecturally there's loads of fine Victorian, including the many hospitals, pubs, civic buildings and schools still found throughout the suburb, as well as scores of the less romantic 1970s redbrick unit block.

Today, Randwick is a bustling place, popular with hospital staff, students from one of Sydney's main universities in nearby Kensington, and Sydneysiders keen to live up the hill from a beach.

VERDICT Beauty? Randwick has a handful of amazing old buildings worthy of closer inspection than a fleeting glance while driving past. I had to restrain myself from running off with all the old cinema letters. And while I was hoping to spend my time at Randwick Racecourse photographing what is surely the world's most beautiful animal – the horse – I thoroughly enjoyed snapping away at all the well-groomed show ponies instead.

what lies behind?

a little dotty >

233

starring the mad hatter

an old queen

wallpaper and tiles

dragon–tiger–elephant man >

campbelltown

MONDAY, 8 MARCH 2010

MATHS ISN'T my strong point but if I'm not mistaken we are at the halfway point of *52 Suburbs*. 26 down, 26 to go. To mark the occasion my car threw a little tantie and refused to move an inch let alone the 51 kilometres required to reach this week's suburb, Campbelltown.

A couple of jumper leads later and I was back in business, all set for my journey to one of the furthest suburbs visited so far on *52 Suburbs*. (In reality 51 kilometres isn't that far. But it seems further than it is because for much of it you're screaming along a major highway in a 110 kilometre per hour zone, pedal to the metal.)

When I learned that once upon a time this faraway place was a big country town, the distance from the city made more sense.

Which leads me to this – it is very hard to imagine a Campbelltown with wide, charming streets and rolling hills on the horizon. There is now an enormous mall and for the most part the lovely old buildings are gone. But ... on either end of the pretty ordinary main strip, a handful of

original beauties remain – focus only on those and you can almost hear the clickety-clack of horses and smell the country air.

Some history. The Dharawal people moved on in 1820 when British Governor Macquarie established a town and named it after his wife, Elizabeth Campbell. Campbelltown spent most of the 20th century as a big country town until it was designated a centre for massive population and residential growth. Today, it's a multicultural mix with a mall.

Luckily, there are also a couple of welcome surprises. One is the Campbelltown Arts Centre and its Japanese Gardens & Teahouse, located just south of the city centre – and yet a million miles from it. Another surprise I stumbled on is a jazz café in the middle of town run by the delightful Kerry, enlivening things no end.

VERDICT While the wide streets and charming streetscape are long gone, at least there's still a handful of lovely old things in Campbelltown as well as a few wonderful new arrivals.

old men and their beards

between the gaps

raindrops

performance places

in the garden

dotted land >

244

< *a fish out of water, the Campbelltown Arts Centre*

ancient lands

Strathfield

WEDNESDAY, 17 MARCH 2010

THIS WEEK I headed to the inner-west suburb of Strathfield, 14 kilometres from the city centre. On my way there I counted up the number of things I knew about the place. I got to one: it had grand old homes.

Turns out the suburb is covered in mansions built in the early 1900s, when Strathfield was country and wealthy families required rural retreats. They are handsome but what really sent my camera snapping were some of the ridiculously grand old institutional buildings – Santa Sabina College and the Australian Catholic University, in particular.

In South Strathfield I also stumbled on the former methodist Leigh College, now an Islamic college, and its neighbour the E. Vickery Memorial, now used by the Sai Baba people as their temple.

Aside from these beauties Strathfield has its fair share of crappy old apartment blocks and crappy new million-dollar homes.

Some history. After the local Aboriginal people were given their marching orders, an area called Liberty Plains was divided up amongst the first free settlers. The settlement then became part of the Redmire Estate, which was later subdivided and sold into lots. In 1885 the suburb was named Strathfield after the name of a wealthy mansion in the area.

While the built environment hasn't changed that much, the demographics certainly have, Of the people I met in Strathfield, 99.9% were Korean, aside from a handful of Russians I ran into in their local church.

VERDICT Beauty? Usually one for the smaller details, I did enjoy the big stuff in Strathfield. I just hope they don't knock down too many more old dears to put up those wicked new houses. Wicked I tell you.

heaven and earth

house of a mere mortal and house of god

church and state (rail)

panda philosophy

< *rainbows*

i love a man in lilac

redfern

TUESDAY, 23 MARCH 2010

I LIVED in Redfern 20 odd years ago as a uni student. And of course I've driven through it since. But I hadn't really *seen* Redfern for a long time until this week.

Take Redfern Oval. It used to be a big old stadium, closed off to the public. Two years ago they knocked it down and replaced it with a part-public, part-sports space and freshened up the adjoining park. What a difference. Two years it's been like that and I hadn't even noticed.

I feel less of a lamebrain for not knowing about Redfern's 'National Centre for Indigenous Excellence', opened just recently to provide facilities for young Indigenous people to help them achieve in sport, art, education and culture.

On a more modest scale, the eastern side of Redfern has also changed a great deal, peppered as it is with bohemian-designer smart.

With so much change in the air, I half expected to find The Block, a crumbling and troubled corner of Redfern, to have undergone a transformation. But no. It looked and felt the same as it's always done.

Some history. Cadigal 'moved on' by the British in the 1790s. Named after the surgeon William Redfern who built a country house in the area. Lebanese moved in during the 1850s and got busy running shops and factories. From the 1920s to the '40s Aboriginal people from all around New South Wales moved to Redfern looking for work. Overcrowding by the 1970s saw the start of a housing project that became The Block.

Redfern today is still home to many things Aboriginal, including dance and radio, as well as plenty of whitefellas from all over the globe, with a mix of the publicly housed, student renters and home owners who like the fact they can live just three kilometres from the city centre without paying through the nose for it.

VERDICT Beauty in Redfern? I was surprised by how much, in a number of ways. And the best thing? That as much as it has changed, it still has its own unique identity, distinct from pretty much any other suburb in the city. Hope they can keep it up.

< *pride*

walkabout

259

Buddy Rose

may the future be bright >

Christine, Teora and Saysha

walkies

Ella

ouch >

264

265

waterloo

WEDNESDAY, 31 MARCH 2010

29

I FOUND Redfern so captivating last week that I decided to stay in the area and visit neighbouring suburb Waterloo. Two consequences of that decision. One, I have had a certain ABBA song on high rotation in my head all week, and two, my suspicion that this is one of the more interesting areas of Sydney has been confirmed.

Why so interesting? Because it's so hard to pin down. Enormous public housing towers watch over swanky café/art gallery patrons, who in turn drink their lattes while observing busloads of Hillsong-ers arrive at their church, just down the road from one of the highest concentrations of Aboriginal people in Sydney. What exactly, I wondered, do the men sitting across in the Salvation Army centre make of it all? In the southern end of the suburb there's a major oval and a skate park, and on the site of the old Waterloo Incinerator, a new 'mini-city', Green Square, is in the making.

Some history. Cadigal until 1788; Irish and English settlers worked in the many industries (brick, glass, brewery, flour, paper) in the

266

area during the 1800s; Chinese market gardeners joined them in the late 19th century until public housing estates were built in the second half of the 20th century. Today, Waterloo is an edgy mix of industrial, trendy retail, and residential (towers and terraces).

By the way, it was named after the Battle of Waterloo of 1815. I just find that so weird. An area that was and still is so Aboriginal named after a war in Belgium, involving the British, their mates and a small French man.

VERDICT For a former swamp Waterloo's got a lot to catch your eye. The old weathered stuff that sits happily decaying alongside the new. The wonderful AGM (Australian Glass Manufacturers) Building, a 1940s 'Inter-War Functionalist style' beauty with an Art Deco tower. And I was lucky enough to visit when one of the galleries along Danks Street was exhibiting work by Aboriginal artist Eileen Napaltjarri. Far from home but close to Sydney's Aboriginal heart, at least.

retail, old and new

it's art baby >

268

black and white

lanterns

lady

skaters >

from the Eastern bloc, now in Waterloo's western block

those girls again >

la perouse

THURSDAY, 8 APRIL 2010

AFTER REDFERN and Waterloo had so successfully sparked my interest in Aboriginal Sydney, I was hungry for more. According to the *Dictionary of Sydney*, La Perouse (or La Pa) is 'the only Sydney suburb where Aboriginal people have kept their territory from settlement until today, and its history is a story of the survival of culture in the face of European invasion.'

Translation: the British tried to kick them out on numerous occasions but failed and today there's a high proportion in La Pa who've been there for generations. Who – now that they don't live in fear of being 'removed' while on their way to the shops for a loaf of bread – are quietly enjoying what has to be one of Sydney's most naturally beautiful suburbs, with the Pacific Ocean on one side, Botany Bay beaches on the other, and masses of green in the middle.

Some history. The Kameygal were happily fishing away when one day a French ship swung into town. The name of the navigator on this French ship? La Perouse. The British later built a watchtower in the area and turned Bare Island into a fort.

Around this time (1800s), if you got the pox or typhoid you were sent to La Pa. Which must have been fun for the Aboriginal people, busy fighting for their own survival. To begin with, most got the boot, with a few allowed to stay on a special reserve. When they were all told to go, around the end of the 1800s and then again in the 1920s and 1960s, they just refused to budge. Finally in 1984 they got ownership and have lived there ever since.

Today, daytrippers come to La Pa to fish, scuba dive or just take in the scenery. While they're enjoying a Mister Whippy ice-cream, they can watch the 'snake-man' do his thing, and maybe buy a boomerang. Which, provided you throw it correctly, is guaranteed to return.

VERDICT I'd never been to La Pa before this week so I had no idea what to expect. But I certainly wasn't prepared for how beautiful it is. Or how peaceful, which is kind of strange considering its history. But there you are, with so much space around you and so much sky above you, you could easily forget all your cares. Except one – do the Mister Whippy vans really re-freeze their ice-cream?

where everything's big except the people

from fort to fishing >

blooming

group hug – Yareen, Shareen and Maui >

'Captain' Jimmy

place of freedom now >

< *camouflage* *Jahra and Ali Grace*

balmain

THURSDAY, 15 APRIL 2010

THIS WEEK I was gripped with a sudden urge to visit one of the city's most inspiring rebirths – Ballast Point Park. Before I knew it I was in the car driving west to Balmain (the neighbouring suburb to Birchgrove where the park is actually located).

While I have been to Ballast Point Park before, I really wanted to share it with you. For most of its history Ballast Point was a green headland occupied by the Eora people. The British then removed great chunks of the sandstone landscape to act as ballast for empty ships returning home. In 1864 a British family built their home on the headland, and in 1928 Caltex followed suit, building massive structures to process and store oil-related products.

Finally in 2009, after 70 plus years as an industrial site and decades of struggle by the local community, Ballast Point was returned to the public as a park. Hence its Aboriginal name, Walama, meaning 'to return'.

But this is no ordinary park. It respects its wide-ranging history by incorporating much of its physical past – fragments of the family's home

as well as some of the tanks and parts of the massive walls from the Caltex period. It's also full of recycled materials, from the orange seatbelt 'shade cloths' to the walls made of recycled rubble.

Quick history of Balmain before we wander. It was Eora Country before British surgeon Dr William Balmain was handed the place. Subdivided in the 1840s, it became very industrial with a large working class living in tiny cottages and working in shipbuilding, boilermaking or Mort's Dock and Engineering Company. Later it produced railway and mining equipment – and in 1891, the Australian Labor Party.

Fast-forward to the late 20th century when Balmain was known for its slightly alternative population, with plenty of pubs, bands and markets. And now? Less herbal and more mainstream. But the housing commission blocks remain, as do the tiny workers cottages. It's just their price tags that have grown enormous.

VERDICT Beauty in Balmain? Tonnes of it – enough to fill one of those empty ships that used to stop by.

of the Eora

recycled

harbour views, framed and unframed

radiance >

c is for curves

and curls

fresh

Maurice wears many hats

woolloomooloo

WEDNESDAY, 21 APRIL 2010

TRICKY. I'm itching to get back out to faraway suburbs but with no time to do so. Hence my choice for Suburb No 32 – Woolloomooloo, 1.5 kilometres east of the city centre.

Prior to this week 'the 'Loo' had only ever been somewhere to drive through in an attempt to avoid a clogged Eastern Distributor.

Turns out – of course – that it's far more than just an 'alternative route', and by the time I left I was completely intrigued by the suburb's past and the extremes of its present.

Some history. Aboriginal forever; First Fleet in; farmland subdivided in 1840s; grand homes built, then smaller workers homes. In 1915 the Finger Wharf was built, the largest wooden structure in the world. But both the wharf and the suburb were left to run down towards the end of the 20th century, earmarked for redevelopment. The wharf was saved and turned into a chic hotel, marina, restaurants and apartments. The rest of the suburb, on the other hand, still struggles, with plenty of public housing and homeless men sleeping rough every night.

Still, it could be a lot worse; in the 1970s everyone was almost kicked out. While that didn't happen, the suburb's centre was virtually destroyed by the massive pylons of the Eastern Suburbs railway viaduct.

Then there's the navy side of the 'Loo. On one of my visits *HMAS Newcastle* was preparing to depart for a tour of Guam, Japan, Canada and Hawaii. Loved ones saying goodbye for four long months. I had a lump in my throat – how must they have been feeling?

It was enough to make you grab a comforting pie from around the corner at Harry's Café de Wheels, still serving peas 'n mash and Hot Dog de Wheels after 70 years.

VERDICT Beauty in the 'Loo? The harbourside part of Woolloomooloo is undeniably sparkly. But I left dazzled mostly by the emotions that run deep within the whole suburb, deeper even than those ridiculous pylons. And the bravery of those willing to fight for what they believe in, from an old wooden building to the freedom of their country.

they've both earned their stripes

hot-dog with a view

06 departing at 0900 for 04 months

one last long kiss

302

dine finely or catch your own – like Jimmy

land rights when?

dural

FRIDAY, 30 APRIL 2010

THE LAST time I'd been to Dural was 30 very long years ago. How much had it changed, I wondered. I was no longer the lanky, spotty teenager my parents used to drag out to the 'country' for the day – so surely it could no longer be the big patch of green it once was.

Expecting the worst – malls, a Westfield, a McDonalds – I was pleasantly surprised. For somewhere that's only 36 kilometres from the city centre, it's still amazingly green, with rolling hills and lots of plant nurseries. But then it's all relative; the locals I met lamented the demise of the huge orchards and market gardens, now broken up into 'small' five- acre residential blocks.

Some history. The Dharug people hung out here originally. Dural comes from the Aboriginal 'Dooral-Dooral', meaning smoking hollow tree. It used to be a much bigger suburb, including present-day Glenorie, Galston, Arcadia and Middle Dural.

Another reason I wanted to visit this area was I was curious to see what happened there on Anzac Day.

306

While there wasn't anything going on in Dural itself, there were two ceremonies in neighbouring suburbs. I arrived late to both: the morning service in umbrella-clad Castle Hill and the afternoon one in bright, sunny Glenorie.

At the latter, the local community gathered around the cenotaph and then the Hills District marching band led the gathering across the road and around the corner to the local RSL club for a couple of bevvies and some fairy floss.

And my last reason to visit Dural? To satisfy my curiosity about a nearby suburb that is partly responsible for inspiring this entire project – Canoelands. Ever since I'd spied it on the map I'd wondered what happens in Canoelands. Not a lot, I discovered. No doubt a lovely, peaceful place to live but slightly less appealing to photograph.

VERDICT Thankfully malls and McDonalds haven't invaded the place, and to my eye Dural has managed to retain so much of its rural beauty. Even if the blocks are only a measly five acres.

< so sad even the angels were crying

1914. 2008. When will it end?

309

the brave

sun salute

checks and tartan

five apiece >

tuning into nature *under wraps >*

314

windsor

34

SUNDAY, 9 MAY 2010

THIS WEEK I decided to take you the furthest we've ever been on *52 Suburbs* – to Windsor, a whopping 60 kilometres north-west of the city centre.

I remember driving through neighbouring suburb Richmond about 15 years ago, on the way back from the country somewhere. I have a vague recollection of driving past Richmond's RAAF base but that's about it.

So I did some 'research'. Settled in 1791, Windsor is the third oldest place of British settlement in Australia. Governor Lachlan Macquarie changed its name from Green Fields to Windsor, after Windsor-on-the-Thames in England. The Hawkesbury River runs through this incredibly flat area, its floods responsible for past tragedies as well as wonderfully fertile soil. And it's famous for a cracker of a church – St Matthew's Church, a Francis Greenway beauty – as well as a handful of lovely old buildings.

Research 'complete', I made the long trek three times to try and get a sense of the suburb. My

biggest discovery? That there are two Windsors – the one during the week and the one on Sunday. The former is quiet, especially so out on the river flats that stretch as far as the eye can see. And then Sunday arrives and it all changes. The place overflows with day-trippers, markets and music. The river buzzes with speedboat races and kayaks. And the main street dazzles with chrome and throbs with the sounds of deluxe touring motorbikes – the bikers are in town, enjoying a few bevies at the Macquarie Arms Hotel, the 'oldest pub in Australia' (1815), before continuing their ride.

Then 12 hours later, back to quiet.

VERDICT Much of Windsor is a floodplain and as a result the area is a major turf producer, making it appear like one giant lawn. I loved this endless lawn as much as the historical old buildings, especially when the skies above were filled with menace. Plus those two, three and four wheelers that roam Windsor's streets. They've got a certain something.

317

< 'For sale. Needs a little work.'

fields of gold

paddling

a flood gauge for the Hawkesbury River

that beer looks so good

men in uniform >

home time >

darlinghurst

MONDAY, 17 MAY 2010

Why 'Darlo', a suburb seemingly familiar? Because last weekend when I went to a photography seminar, it happened to be held at the amazing old Darlinghurst Gaol – now the National Art School (NAS) – and I needed to go back. Despite having driven past that long stretch of golden sandstone many times, I had never once set foot inside. In fact, I assumed it was part of the Court House – which made me also realise, that I'd never visited that grand old beauty either. So, once again, a suburb, though familiar, turns out to be surprisingly foreign.

To Darlo. Named after Elizabeth Darling, wife of Governor Ralph Darling (and 'hurst', an old English word meaning wooded area). The suburb was a long-time slum now turned swanky, bursting at the seams with cafés, pubs, restaurants and nightclubs – and some heavy-duty institutions aside from the Court House and NAS, including the Australian Museum, Jewish Museum and St Vincent's Hospital.

There's so much to cover in this large and jam-packed suburb I ended up leaving out large chunks. I'll save them

for when I do *52 Suburbs Revisited*, when I'm old and grey!

Today, NAS hangs art not people with a collection of wonderfully rotund, golden buildings built by convict labour in 1836–40. (Last hanging, 1907. Sure to be haunted.) NAS may have liberated the gaol from its former role but its neighbour, the Darlinghurst Court House, still functions as a place of judgment. Architect is Mortimer Lewis; built in 1844 in the Greek Revival style (they loved a column didn't they?).

The other inhabitants of Darlo are the fireies and the ambos – where would we be without them? The ones based in Darlo are lucky enough to call a heritage-listed fire station and one of the city's major hospitals, St Vincent's, 'home'. It's hard work but at least they're never short of good coffee.

VERDICT Beauty in Darlo? The grand and not so grand. The streets that support all walks of life. And those charcoal drawings from great artists of tomorrow.

along the same lines

a certain kind of liberty

< hey, that's my bone!

pillars of society

fire engine red lips

unless interestingly attired

regal Marie

pastels

botany

MONDAY, 24 MAY 2010

36

I HAVE to be honest. I spent my first half hour in Botany wondering what other suburb I could do instead. Then slowly but surely this enigma of a suburb revealed its secrets, one by one. So much so that by my last afternoon in the place I found myself wondering how I could move there.

Some history. Dharawal people first in. Captain James Cook lands in 1770 along with botanist Joseph Banks. As a result the area is called Botany Bay and the suburb, Botany. Fishing village then industrial, albeit with a popular 'resort' and zoo, the Sir Joseph Banks Hotel on the then shores of the bay (now reclaimed). While still very old Sydney suburban, a 'new Botany' appears to be emerging, helped along by the recent influx of inner-city and eastern suburbs types seeking a home without a choking mortgage.

A few facts about the old hotel. The original Sir Joseph Banks (SJB) Hotel was built in 1844. It sat right on the bay and included the first zoo in Australia, with creatures from all over the world. Since then a lot has changed: the sea was filled in to create more land so that SJB

now sits on the edge of green not blue. And the hotel is no longer a hotel but five separate apartments. In 1987 the Pleasure Gardens were created around the building as a reminder of what once was.

And my dramatic shift in attitude towards Botany? Well, it was definitely helped by my 'education' at the local school. I just happened to be in the area when Botany Public School was opening its 'historic pathway'. Listening to the speeches given by school staff, former students and the deputy mayor of Botany, I quickly realised how much depth and history the suburb has. The school began life in 1848, making it the oldest public school in New South Wales.

But I also found 'new' Botany appealing with its café-yoga-art-gallery and a baking school down the road specialising in sourdough. Sure signs that Botany is indeed changing – that and the fact that real estate is no longer a steal.

VERDICT Is there beauty in Botany? A whole load more than I would ever have imagined.

day trippers arrived by carriage, then tram, then car

former students – father and daughter >

Melrose – he's half and half

let's call him Keith

i do believe that is a rare form of flower kind sir

Pandanus Tectorius >

the changing face of Botany – Jeff and Andrew

Zahra

sydney cbd

TUESDAY, 1 JUNE 2010

THE CITY? As in, the Big Smoke? Well yes, but apparently it is a suburb. Because I'm city-based for another photographic project I've just started, I sort of had to make Sydney's CBD this week's suburb. But it meant I could finally explore on foot some of the amazing buildings that I've driven past so many times, rushing to work or whatever.

As you'd expect, this is where you find all the big cheeses. Culturally you've got the Museum of Sydney, the State Library of New South Wales, the City of Sydney Library, the Theatre Royal, the City Recital Hall and the Japan Foundation. Then there's the Sydney Opera House, the Museum of Contemporary Art, the Australian Museum and the Art Gallery of New South Wales.

Park-wise there's Hyde Park, the Domain, Royal Botanic Gardens and Wynyard Park.

As wonderful as all these buildings and sprawling green spaces are, I failed to photograph every single one of them. I thought I'd have time to but no. But I did at least manage a few snaps of the sandstone beauties along Bridge Street and some of

the interior delights of the Sydney Town Hall. Oh, and that incredibly wonderful installation outside the Museum of Sydney, *Edge of the Trees* by Janet Laurence and Fiona Foley. If you've never meandered through this 'forest' of sandstone, wood and steel, I recommend it highly. And by the way, if you think you're hearing voices as you move between the pillars, you're not going crazy. They're Koori voices reciting the names of places around Sydney pre-colonisation.

Macquarie Street is another interesting place for a slow trawl, a historic precinct that stars such buildings as the State Parliament House and the Supreme Court of New South Wales. In case you're not acquainted with the life and times of Lachlan and Elizabeth Macquarie, an explanation in 20 words or less: arriving in 1810 they basically built Sydney, were into the arts and gave poor old buggers like convict Francis Greenway a second chance.

VERDICT Is there beauty in Sydney's CBD? There's loads of it. If they could just do something about that Monorail track.

department of cool

bondage >

349

flowers

marks of history

brollies

hello sailor!

colourful glass

old style

bonnyrigg

WEDNESDAY, 9 JUNE 2010

TOURISTS DON'T come to Sydney to visit Bonnyrigg. I'd bet money on it. But more's the pity. Because this little-known suburb, 36 kilometres from the city centre, is intriguing – something neither the Sydney Harbour Bridge nor Opera House, as iconic and wonderful as they are, can claim to be.

I stumbled on Bonnyrigg completely by accident. I was actually headed for Fairfield. Took a right instead of a left and there I was. In the religious hub of the universe.

My first 'you're kidding me' moment was the Cambodian Buddhist Temple, a golden temple reaching up into the heavens, sandwiched between acres of new housing and a super-sized Bunnings hardware. Good but the best was yet to come. After annoying the monks at the temple, I whizzed around the corner, past an enormous plaza, to discover a small street with a Chinese Presbyterian Church sitting next to a Turkish mosque, which in turn was next to a Vietnamese Buddhist Temple. And then, impossibly, around the next corner, another

temple, the Lao Buddhist Temple. I was blown away. So much so I could not believe my peepers the next day when I found yet another temple in the area, the Mingyue Lay Temple, one of the largest Chinese Buddhist temples in the Southern Hemisphere, housing 37 bronze buddhas. What was going on?

I later discovered, while attending an open day at the mosque, that the reason for such a rich cluster of religious houses in one spot was that years ago the Department of Housing had offered land to any community groups who wanted it. A big carrot but the result is pretty amazing.

VERDICT B is for beautiful Bonnyrigg. Well, parts of it, anyway. Once an important Aboriginal meeting place, then market gardens, it is now covered with 'new' housing development, with more to come. But I almost didn't see the blond brick, so taken was I with all the religious houses. Aside from that, Bonnyrigg feels like one big experiment – I wonder how it will all turn out.

prayer

even the flowers are saffron

beads

neighbours – Islam and Buddhism >

362

363

pool then prayer

autumn colours

< *Turkey in Bonnyrigg*

columns

arncliffe

THURSDAY, 17 JUNE 2010

ANOTHER HAPPY accident. Last week, on my way to Fairfield (which turned out to be Bonnyrigg), I got so lost that I ended up southish instead of west. My attempt at a 'short cut' had failed miserably, but even with steam issuing out both ears, I noticed the suburb I was lost in was kind of interesting and that maybe I should come back and visit.

So I did. Arncliffe, as it turned out to be, is 11 kilometres south of the CBD and named after an English village. Once a big market garden, it's now semi-industrial with a huge new residential area going up in what used to be North Arncliffe. Post the 'Aboriginal era' came British, Irish, Germans, Chinese. Then Greek, Macedonian, Yugoslavian. And, most recently, Lebanese.

Hence the presence of one of Sydney's larger mosques, Al Zahra. There's also a second, smaller mosque that caters to more of a Malaysian crowd, and a handful of churches, including a Coptic Orthodox church (Egyptian).

I had no idea about the mosques or the Coptic church when I drove through last week, so it was kind

of weird after Bonnyrigg and its religious smorgasbord. Having said that, there wasn't a stick of incense or glimpse of saffron to be found in Arncliffe – a little like Lakemba, this is Sydney in Muslim mode – with the Coptic Orthodox Christians slap-bang in the middle, just to keep things interesting.

The other main focus in Arncliffe seems to be the Lebanese bakeries. I discovered that Lebanese families bring their own mince mix to the bakery to be fashioned into 'meat pies' by the ladies who work there. They just pay for the dough and whatever it costs to cook the pies in the super-hot ovens. (Do you think it could catch on elsewhere?)

VERDICT Did I find beauty in Arncliffe? In the people as much as anything – I loved the Lebanese women in the bakeries and the Egyptians in the church. But it's the only suburb in which I've ever been refused a shot of someone's tattoo. Unbelievable.

< kitchen whiz

Anglican Church and Alzahra Bakery

tiles and temptation :: 1

tiles and temptation :: 2

orange

beauty that can't be covered >

the Coptic Church and the Chapel

attracting young families

kirribilli

TUESDAY, 29 JUNE 2010

40

I WAS thrashing about trying to decide which suburb to do this week when suddenly, overnight, Australia got a new boss. A new PM – and Australia's first female one at that. I started thinking about Julia Gillard's life and how it would change. Where, for example, would she live, I wondered. Which put Kirribilli in my mind, Kirribilli House being the official Sydney PM pad.

I was also curious if my perception of Kirribilli as a sort of 'non-suburb' made up of one PM and heaps of professional types would change once under the *52 Suburbs* microscope.

So what did I discover when I actually got out of my car, walked around and met the locals? That Kirribilli is home to an incredible mix of people, not just the well-heeled. Sure, there's money there, evidenced by the private-school kids that turn the main street into a sea of royal blue at lunchtimes. But there's also the people in Greenway public housing who pay 25% of their Centrelink payments in rent to live in one of the most expensive suburbs in Sydney.

I must have driven past Greenway thousands of times – as you drive

across the Bridge heading south you can just see the top of it peeking out. But until I met one of the residents, the lovely Isabella, I'd never been curious about it. When I went to check it out, one of the things that surprised me the most was the huge thriving vegie patch out the back.

I also discovered that as salubrious as Kirribilli's address is, there's a sense of community there that wouldn't seem out of place in a small country town. If you don't believe me, hang out in Margaret's Café down by the wharf for half an hour. Great grub but the chat is ever better.

Some facts. Name means top fishing spot, from the Aboriginal Kiarabilli. First residents were the Cammeraygal people. Admiralty House began life as Wotonga in the 1840s. Ensemble Theatre started up in 1960.

VERDICT The beauty to me in Kirribilli is the way the suburb winds around skinny streets, its charming old apartment blocks, and the feeling you get that if you needed help, your neighbour would rally to the cause. No matter how different you are.

379

jagged lines

maybe one day I'll be a garden gnome

Deb in the vegie patch >

383

public housing with a million-dollar view

great grandma and the finches

young love

a sea of blue next to the harbour

< neighbours

Greenway residents

collaroy

FRIDAY, 9 JULY 2010

STAYING NORTH this week I headed to Collaroy on the Northern Beaches, 22 clicks from the big smoke. Even though I lived in Avalon for a number of years, I would rarely drive through Collaroy, choosing the Wakehurst Parkway instead. In fact, the only time I've ever actually visited Collaroy was a zillion years ago to visit my nan who lived in the Salvation Army home there.

I adored my nan and I remember every detail of her tiny room at the home, packed full of her life's treasures. Hence the flood of nostalgia as I pulled into Collaroy on a grey, rainy day with fantastic stormy skies brewing over the ocean.

The suburb also strikes me as old-worldly for other reasons aside from my nan. Because it's on a main road, it's been saved from too much trendification and café-ifying. Apart from one new beach-themed café, there's an old Art Deco cinema with peeling paint, a tiny Indian restaurant and a few other shops.

Collaroy is so much about the beach, really – all 3.4 kilometres of it (when you include Narabeen Beach too). In fact, it was named after SS *Collaroy*,

which ran aground on the beach in 1881. Perhaps unwisely, many of the homes and apartment blocks have been built right on the edge of the sand – if storm surge doesn't get them, climate change might.

One of the highlights of my visits to Collaroy included seeing the suburb from the roof of one of the tallest buildings in the area, Flight Deck.

The other was meeting Madge, almost 90, in her powder-pink hat and teal blue coat. I told her she reminded me of my nan and could I please take a photo of her on the beach. She smiled, took my arm and we crossed the street to take the shot. When I left I told her I'd never forget her. 'And I'll never forget you, Louise.' Gulp.

VERDICT Did I find beauty in Collaroy? The brooding skies, the nostalgia, a couple of retro buildings clinging furiously to the sand, and Madge. Beautiful Madge.

Madge in pink

the fabulous four >

spiky things

atop Flight Deck >

colourful Collaroy

front-row seats >

manly

MONDAY, 19 JULY 2010

MANLY? I hadn't been for years and when I scoured my memory for an image of the suburb, this is what turned up: tacky shops and hordes of tourists ambling mindlessly around.

So what did I discover? That, der, Manly is so much more than just the beach and The Corso (and even The Corso is better than it once was). Because five minutes from tack and tourists is another world, otherwise known as North Head, part of Sydney Harbour National Park.

Not only does North Head have some amazing bushwalks, with beautiful wetlands and spectacular harbour views, it also happens to house two incredible built environments. The first is the former Quarantine Station from the early 1800s. Once used to hose people down with carbolic acid and confine them for 40 days, Q Station is now a wonderful collection of charming wooden buildings where you can stay a night in four-star comfort – and only wish you had to stay for 40.

The other extraordinary complex at North Head is the former School of Artillery, a grand Art Deco creation

from the 1930s that is now used for shoots and various other endeavours.

Aside from the delights of North Head, there's also a lovely walk around the headland to Shelly Beach and the mother of all buildings perched high on the hill, St Patrick's Seminary, where Tony Abbott once trained as a priest before switching over to politics.

A few facts before we wander. Governor Phillip, inspired by the manly behaviour of the Guringai people, named the area Manly (when later speared by one of these manly men, he acted quite manly himself and didn't make a big fuss). Big holiday resort in the early 1900s, as long as you were prepared to wear neck-to-knee swimmers. Today, the place attracts tourists by the ferry-load, keen to take advantage of Manly's beaches and its unique setting on both the harbour and ocean.

VERDICT Manly has a vivid, other-worldly, steeped-in-history sort of beauty. And personally, I like those two white apartment blocks that locals refer to sneeringly as the 'Toilet Rolls'. So there.

just hanging

merry Manly >

< ghosts still roam Q station, even camera-toting ones

flight

orange flowers

the road less travelled

swimmers

walk on water >

408

vaucluse

WEDNESDAY, 28 JULY 2010

WHEN I visited Arncliffe a while back, I asked a Lebanese guy if I could take a shot of his tattoo. His response: 'No way, go to Vaucluse if you want that sort of thing. This is Arncliffe!'

I'm not entirely sure what he meant, but I suspect he sees Vaucluse in the same way many do – as an elite suburb filled with wealthy white people who, if they had a tattoo, would politely agree to me taking a snap of it.

But was that really all Vaucluse was? A suburb of rich people?

Curiosity had set in and there was nothing for it but to revisit a suburb I hadn't been to for eons and have a sticky.

What did I discover? That yes, Vaucluse is full to the brim with smart cars and mansions. But while most of Vaucluse belongs to the elite, its fringes – the really good bits with beaches, parks and amazing views – belong to everyone, as do a handful of its historic buildings. As far as its locals go, I searched but found few. Instead, almost all the people I met were daytrippers relaxing in parks

and on beaches, or the hired help for some of the homes.

And tattoos? One. From someone working in a café. It was such a good one I forgot to ask if she was a local.

Some history. Dharug people enjoyed the peninsula setting, with its harbour and ocean views, for most of the time until the British moved in. The Brits quickly shot up a signal station and lighthouse to guide ships to the colony. The suburb has a handful of significant buildings, including the present-day signal station and lighthouse, Vaucluse House, Strickland House and Greycliffe House. Plus a whole load of great parks, reserves and walks. If you're into cemeteries, there's a fine one at South Head, just up the road from The Gap.

VERDICT Is there beauty in Vaucluse? Thanks to the wise men and women who campaigned for public access way back when, and those who now care for the historic buildings with respect and dedication, yes. Vaucluse would be much poorer without them.

< *tiny buttons*

alll prayers appreciated

big blue eyes

Mira >

414

415

eye-popping bubbles

flying ladies

vivid

house in garden >

hope i don't end up on that table

getting your hands dirty

hurstville

THURSDAY, 5 AUGUST 2010

44

HURSTVILLE. Last time I went I was a lanky kid in a white skivvy and flares, clutching a bag of multi-coloured popcorn in one hand and my dear old nan in the other.

Growing up in Hong Kong, we'd come back to Sydney to visit rellies every few years. My brother and I would always spend a few days at my nanny's place in Hurstville (before she moved to Collaroy). My memory can be pretty shocking but I vividly recall so much about those times. Nan's generous nature and easy laugh. Sitting in front of the TV at 6 am watching *Lost in Space*. Visiting Roselands shopping centre.

But I could not remember for the life of me where she actually lived in Hurstville. With my mum long gone, my family struggled too. Finally my brother had a flash – Carrington Avenue. While he couldn't recall the number, he remembered it was within 50 metres of the main road.

So this week, decades after those childhood visits, I headed south-west to Hurstville. First stop, Carrington Avenue. I was so excited to have finally made it there, but after

422

scouring every inch of the street, and speaking to someone who's been there for ages, I realised that her little house had probably been demolished long ago.

What made the visit to Hurstville even more nostalgic was that it's now a sort of mini Hong Kong, the place I grew up in from ages 6 to 16. So even though it's so changed from the Hurstville of my nan's day, it was very familiar, in a HK sort of way.

Anyway. Apologies for the hand-wringing but I wanted to let you know the backstory to my visit to Suburb No 44 (which, by the way, means double death in Chinese – eek!).

And now for some backstory of the suburb itself: 16 kilometres from the city. Name is a combination of 'forest wood' and 'town'. People wise: Eora, then British, then Greek and Italians, Macedonians, then Chinese, and more recently New Zealanders.

VERDICT I left Hurstville filled with images of births, deaths and marriages – in a variety of ethnicities. That was the beauty, right there.

the east of the west

the new Union Jack

fire, fire!

vacant for just a moment >

growing up Australian in 'Chinatown'

a temporary tattoo

the Chinese Baby Bjorn

< copper and coffee pots

intricate patterns

433

Demi and Roy

Mary

dulwich hill

MONDAY, 16 AUGUST 2010

WHY 'DULLY', eight kilometres from the city centre? Well, I kept hearing about people who loved living there and was curious. Just up the road from the thriving suburb of Marrickville, maybe it would be similar, I thought.

Not really, it turns out. While Marrickville bustles, Dulwich Hill quietly snoozes. So much so that when I first arrived I really did wonder what all the fuss was about. Then slowly it grew on me and I realised Dully's relative calm is part of its appeal.

A handful of the shops haven't changed for 30 years, still run by the original Greek and Italian migrant owners. Like George, the tailor who'll whip up your hem for $10 and give you a sermon on socialism for free. Anastasia and Con who run Thessaloniki, a cake shop. Luigi's Bakery where the bread flies out the door by noon. And David Kasmaroski's Eumundi Smokehouse (okay, he's actually Russian but you get the idea).

A few facts. Started out in life as Petersham Hill, then Wardell's

Bush, then South Petersham and then Fern Hill. Finally ended up as Dulwich Hill, after Dulwich in the old Dart. Variety of architectural styles, from Romanesque to Federation. Experienced waves of migration, from Greeks and Portuguese to Pacific Islanders, Africans, Vietnamese and Chinese. Most recently it's been young Anglo families desperately searching for affordable real estate without sacrificing good coffee. Forty-seven different nationalities now attend the local public school.

The new arrival that's got everyone talking, however, is Gleebooks. And after a long wait, Dully will also be getting the light rail extension within the foreseeable future. Too much excitement indeed.

VERDICT The beauty in Dulwich Hill? The slow reveal, its lack of pretension and the fact that all those different nationalities can go to school together – and, I'm told, all get along.

diamonds

bright lights

Hajara and Hamja from Bangladesh >

those were the days

eek, my hair matches my house

leathers

Gregory Athanassiou and his lucky charms

loneliness

rock and roll baby >

summer hill

WEDNESDAY, 25 AUGUST 2010

46

AS SO often happens on *52 Suburbs*, this week's suburb was sparked by last week's. Hanging around in Dulwich Hill I kept hearing about neighbouring Summer Hill. I'd never been but I remembered that 20 years ago someone's boyfriend lived there – and although I'd never visited, I used to think: poor guy, living all the way out in *Summer Hill*.

Was it still that bad, I wondered? It was, after all, right next door to delightful 'Dully'. How different could it be?

Quite different actually. For a start, 'Summer' doesn't have two main roads coursing through it like Dully so it feels calmer, more village-like. While Dully has a handful of wonderfully original shops still run by their original owners, Summer has a range of 'pretty shops', more cafés and restaurants. And while Dully is multicultural, Summer seems more Anglo with more professional types – they have to be to pay the heftier mortgages. (That said, Summer also boasts a whopping great Chinese temple, the Wong Tai Sin and Kwan Yin Kur temple, on its border with extremely Asian Ashfield.)

448

So yes, different to Dully – and very different to my previous perception. As a long-time tailor there told me, 20 years ago nothing much was going on in Summer Hill. Now, 'it's all happening'.

History in brief. Originally home to the Wangal and Cadigal people – and an unusually high number of kangaroos. First white property ownership in 1794 by a former convict and gaoler, Henry Kable. Named after somewhere in Britain. Suburb of toffs in the 1920s with mansions aplenty, but by the mid-1900s, working-class. Today, a few mansions survive with a mix of Federation homes and apartment blocks. Increasingly populated by young families who can afford the exy real estate.

VERDICT The beauty for me – that your stroll through a 'village' with a vaguely European feel could end with a visit to a temple so smoky with incense you smell like a forest fire for days after.

449

former flour mill, once used to make pizzas

light

Gus, the busy butcher

rare, medium or well-done? >

453

fellow musicians

oranges, from tree to temple

Alan, former photographer >

455

paddington

SUNDAY, 5 SEPTEMBER 2010

I HAD planned on venturing far out west this week. Instead, I ended up just three clicks from the city centre. What happened? Well, I really did intend to let my jalopy have its head – until I read that a festival was going to be on that weekend in the suburb of Paddington. As 'Paddo' is on my Last Few Suburbs list, I decided to veer east, not west, and go look.

Now, I should say, I began my visit to Paddo with mixed feelings. Love the current incarnation of the Paddington Reservoir as well as the history of the suburb. But not so enamoured with the claustrophobic streets and all the pretentious 'look at me' types (aside from one fabulous person, and I'm not just saying that because she's my publisher).

Hence, I can count on half a hand the number of times I've visited in the last decade. Would I view the suburb any more positively if I actually got out of my car and walked around – especially during a festival?

Yes, in the main. As part of the festival, William Street, Paddo's boutique shopping strip, was transformed into a car-free street party. The place

458

seemed instantly less uptight, and I met enough down-to-earth locals to realise it wasn't all about fashion and hair – and that many of the 'look at mes' aren't locals, anyway.

And really, how bad can a place be that has two excellent bookshops, masses of art galleries and pubs, and one kiss-ass example of adaptive reuse, Paddington Reservoir?

Some history. Named after London's Paddo. Cadigal tossed out, British moved in. Fine Georgian mansion, Juniper Hall, and Victoria Barracks built in the 1800s. Late 1800s, squillions of terraces built to house workers. Overcrowded and slum-like until the 1960s when it began to metamorphose into a desirable residence with million-dollar price tags.

VERDICT While it does seem to be blessed with more than its fair share of Beautiful People, there's nothing wrong with that (I too would like flawless skin and firmer thighs). But for me the true beauty lies below the surface – in the Reservoir – and above ground in the occasional colourful character.

459

white lace

waiting for the bride >

wash day?

look, no cars – William Street Laneway Festival >

< curls

a match made in '50s heaven

tyres and bangles

Elle >

466

< *reservoir reborn* *golden lace*

penrith

MONDAY, 13 SEPTEMBER 2010

WOO HOO! Managed to break out of the city limits this week and head 50 kilometres west to the edge of Sydney – Penrith. Windows down, music blaring, my mini road trip was all the more exciting because while I've driven past Penrith at 110 kilometres an hour en route to the Blue Mountains many times, I've never once thought to pull off the highway and explore.

In my mind Penrith always conjured up a picture of hot and dry and not much else. So I was just a little surprised/ashamed to discover that it sits on the banks of a huge river and boasts a major performing arts complex, 'the Joan'.

What was possibly even more shocking, however, was feeling like I'd strayed into Las Vegas somehow when I came across the Panthers World of Entertainment, an enormous resort-like affair right opposite Penrith Stadium, home to the Penrith Panthers.

But really, what made Penrith for me was the people I met. From a lively group of disabled people performing at the Joan to a striking tattooed couple doing the groceries. And

470

Pasha, an Arabian stallion with a plaited snow-white mane that I couldn't stop photographing.

Some history before we look. Dharug people happily fishing away when the British showed up. In 1810 Governor Macquarie named his five top towns, one of which was Castlereagh just up the road from Penrith. But Penrith took off instead due to the fact a whopping great highway ran through it. When the railway came to town in 1863, Penrith really bloomed, then again during World War II, and once more in the 1970s. Penrith takes its name from another Penrith by the river in Cumbria, England.

VERDICT As I said, the highlights of my visit to Penrith were the people I met and perfectly plaited Pasha. And while I don't follow rugby league, I do appreciate the passion. So much so I found myself scanning the sports pages this morning for news of the Panthers game. My condolences. Who do those Canberra Raiders think they are, anyway?

Can you believe it, just four more suburbs to go?

471

< even glamorous Gypsy types have to get the groceries

Wolf and Swan

< then the bird gave the unicorn a flower

i am eagle, you are chair

477

< Tammy, 'I just love pink'

the boys arrive at the game

Macquarie sailed up the river

scarves and pearls >

maroubra

TUESDAY, 21 SEPTEMBER 2010

AFTER HANGING out west in the 'Riff' last week, I thought I'd head back east to the 'Bra' – Maroubra, 10 kilometres south-east of the city centre. Not entirely sure why but I suspect it's because some part of my brain regards Maroubra as a classic Sydney suburb, despite the fact I've never explored it beyond the house of some friends who live there.

What did I find? A beach suburb that has managed to resist the tidal wave of hip and groove that has transformed its northern neighbours. While Bondi, Tamarama, Bronte and Coogee struggle to keep up with the fashion of the day, Maroubra doesn't seem to give a damn. Where else, for example, can you find a greasy garage filled with cars in various states of undress right on the beachfront? Or a massive 'sports and community club' enjoying the ocean views instead of a dozen trendy bars and restaurants or trashy fast food joints?

What is also striking about the Bra is the mix of people who live there, from residents of the Coral Sea Housing Estate to urban professional weekend-surfer types. I don't imagine

it's all smooth sailing, but there's a general feeling of friendliness – and an understanding that this is not a place to have tickets on oneself.

Some facts. Name means 'windy place' or 'like thunder'. Didn't really take off until the 1910s when Herbert Dudley carved up some land, and in 1921 when the tramline was extended down to the beach.

Boomed after the 1950s when Chinese, Greek, Indonesian, Italian and Spanish moved to the area for the cheapish housing and beach lifestyle. The main shopping strip, Maroubra Junction, once ruled the roost until Bondi Junction took over the mantle of premier Eastern Suburbs shopping mecca. The Bra remains a favourite of hardcore surfers and surfie gang, the Bra Boys.

VERDICT What's appealing about Maroubra is the feeling you get that the elements – sun, wind and water – dominate, and that as long as the surf keeps pumping, the paint can keep peeling and no-one will care.

flowers

butterflies

< a couple of semis

Dave and Nancy

puppy love

the beach all to himself >

so do not enter Eleni's Greek cake shop

from the Middle East to Maroubra Junction >

granville

TUESDAY, 28 SEPTEMBER 2010

WITH ONLY three suburbs to go, the pressure was on this week to choose a 'burb of some significance. But not one to bow to expectation, I decided to pick a suburb I'd never thought of visiting. It wasn't quite as random as throwing a dart at the map, but almost. After some perusal I settled on Granville, 22 kilometres west of the CBD.

I had no reason to go – but would I find one once I'd gone? In other words, would I prove my theory that if you walk slow and look hard you can always find something of interest and beauty?

I'll admit it was tough going at first. But just as I was losing hope, I found a decent enough piece of wall to scrutinise and photograph. And by the time I bid the suburb farewell three days later, I'd begun to understand how Granville ticked and I was turning into a fan.

In particular, I loved the way the various cultures that inhabit the suburb transform a fairly nondescript main street into a moving spectacle. Giggly Lebanese girls all dolled up for their formal, awaiting the stretch

Hummer. Hundreds of Tongans kitted out in national dress for a 21st birthday. Burly men kicking back with hubbly bubbly in the same café as a Pakistani Imam enjoying his afternoon coffee. African schoolgirls gliding down the road on the longest legs you've ever seen. And hunky Lebanese body builders in tiny tops on parade. This is Sydney 2010, I thought – and I like it.

Some facts. Aboriginal land for most of time until the British arrived. Originally known as Parramatta Junction, it was renamed Granville in 1880 after a British earl. Once harvested for its wood, then, when that was gone, dairy cattle had a go at its grass.

VERDICT In 2000 the Lord Mayor of Parramatta called Granville 'the most urban decayed area in Sydney'. But what I saw mainly was colour and movement, thanks to the ability of ancient cultures to adapt and thrive in the suburbs. That and a rare original Art Deco cinema, its beauty wholly intact.

an Aladdin's cave of sweet things

lights, camera, action

best buddies, Emne and Sarah

Ray >

< beauty well preserved

sunlight dances into the ballroom

< island girl

pointy red things

mourning suit, Tongan style

Terry and Sam >

alexandria

THURSDAY, 7 OCTOBER 2010

THE PENULTIMATE suburb is … Alexandria, four kilometres south of the CBD. Why? Because it was here that many of the bricks that built the suburbs I've just spent 50 weeks exploring were made (in the former brickworks, now part of Alexandria's Sydney Park). How could I not?

And while I had visited Sydney Park before, I'd never wandered aimlessly, just for the hell of it. Never made the trek over to the wetlands area. And I'd certainly never nosed around the former brick kilns or chimneys that played such a starring role in building Sydney. Here was my chance.

Aside from that, I didn't have high expectations. There was the Mitchell Road Antique and Design Gallery, and I'd probably find some nice old industrial bits in the suburb too. That would be about it, I thought. To my great delight, I was wrong. I stumbled on an original temple 'village' from the 1870s that transported me across the oceans and back in time. And I discovered another surprising and colourful corner of Alexandria on Belmont Street at 'Piazza Belmonte'.

Some history before we roam. No doubt the Cadigal people enjoyed the forest of turpentine and ironbark trees in the area until 1788 rolled around. Their home was then renamed Alexandria after Princess Alexandria, wife of King Edward VII. By 1943 the suburb was the largest industrial district in Australia, churning out everything from bricks to aeroplanes in the 550 factories.

Industrial with a healthy dose of Chinese market gardens to keep people in greens.

Today, Alexandria is still largely industrial with pockets of surprisingly quiet residential. Having said that, you can almost see the place changing before your eyes. Warehouses morphing into trendy business complexes. Chic apartments springing up all over the joint. And at least three excellent cafés that wouldn't be caught dead offering a sticky bun or lamington.

VERDICT Beauty in Alexandria? There's brick loads of it in Sydney Park. And I loved my 'trips' to the unexpected corners of the suburb. Enjoy your wander and then see you next week for the 52nd suburb!

< best mates, Hamish and Tony

surviving, just

< baby Mabel, just three weeks old

amber liquid

light, there are so many ways to love you

alphabet house

513

happy in anyone's language

19th-century life in 21st-century Alexandria >

milsons point

SUNDAY, 17 OCTOBER 2010

AFTER JUST over a year of daytripping around this amazing city, we have finally arrived at our last stop – Suburb No 52. It's a very strange feeling, a potent mix of sadness, relief and satisfaction. In fact, every time someone has asked me what I'm planning to do to celebrate the end of 52 *Suburbs*, I've felt quite disturbed. I know what they mean and appreciate the sentiment – but celebrate? Part of me never wants this to end.

So, why Milsons Point? When I began this project I was insatiably curious about the Sydney beyond the postcard clichés. 50-something weeks later, I feel like I at least have some idea about that city. Time to do an about-turn and pay a visit to a suburb packed with icons that scream Sydney to millions around the world. Because I never said I didn't like the shiny glistening bits. They just had to wait their turn.

Knowing that the last suburb had the potential to be a bit sad, I also wanted to share something fun with you and end on a high note, somehow. A trip to Luna Park, the fun fair at Milsons Point, seemed like

a good idea. Especially as fun and fantasy are where we started with the 1950s Fair at Wahroonga. Why not end with it too?

Some history before we hop on the ferris wheel. The Cammeraygal lived along the foreshores of the area until the British arrived. The suburb was named after settler James Milson. In the 1920s many of the suburb's homes were resumed to make way for the building of the bridge and railway. Luna Park began in 1935 but suffered a terrible tragedy in 1979 when a fire killed seven people on the Ghost Train. Today, Milsons Point is a mix of high-rise residential and commercial, its most notable bits being one end of the Sydney Harbour Bridge, Luna Park and North Sydney Pool.

VERDICT While the icons pack a punch, I like the kinetic energy of the place. Trains, cars, buses, cyclists. Runners, swimmers, thrill seekers. A suburb in constant motion.

517

< eyelashes

peeping Tom

sea creatures

wheels

Chris and Shannon from Mount Druitt >

522

neighbours

nice place to work on a tan

postscript

A FEW FINAL WORDS

Like anything good that comes to an end, the feeling of finishing *52 Suburbs* is bittersweet. But when I reflect back on the project, I am struck by the thought that it could so easily have never happened. Then I just feel full of glee and gratitude that it did.

Who knows what's next? If I had another lifetime, I think I'd push on until the 683rd suburb of Sydney. But despite the fact I only visited 52 suburbs, it was enough for me to get a good idea of this place I call home.

I hope you enjoyed my year of suburban exploring. I certainly did. Every hot, cold, hard, easy, exhausting, funny, disturbing, curious, satisfying, beautiful, ugly, wonderful minute of it.

STOP PRESS As we go to print I've just learnt that the *52 Suburbs* blog will be archived in perpetuity by the State Library of New South Wales which means it will continue to live on. Forever. Very cool.

I GIVE THANKS

Enormous, heartfelt thanks to everyone who allowed me to photograph them. You didn't have to stop for a lady waving a camera around. But I'm so glad you did. I hope you like what you see.

To my 'travelling companions', the wonderful souls who followed the blog. It made the world of difference to share the adventure with you.

To the fabulous women at UNSW Press, Phillipa McGuinness, Di Quick and Chantal Gibbs.

To those I called on for technical advice when I was preparing my images for the book. Peter Lang. Casandra Anguita Deep. Brent Wilson. Moshe Rosenzveig. Murray Vanderveer. Ted Blore. Uge. Andrew Goldie.

To my beautiful friends and family for all your support. A special thanks to the smart and talented Anne Sutherland, Kate Sweetapple and Tania Burkett for your excellent eye and wise counsel.